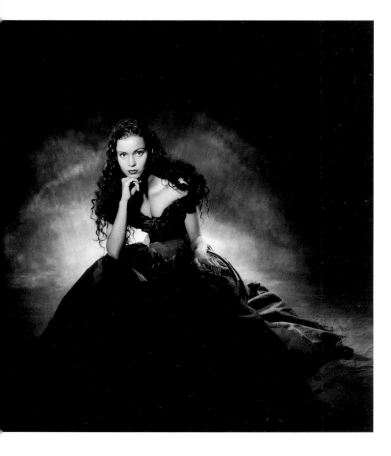

Special Occasion
Photography

ROTOVISION
PRO-PHOTO SERIES

Special Occasion
Photography

JONATHAN HILTON

A RotoVision Book

Published and Distributed by RotoVision SA
Rue Du Bugnon 7
CH-1299 Crans-Près-Céligny
Switzerland

RotoVision SA, Sales and Production Office
Sheridan House, 112/116A Western Road
Hove, East Sussex BN3 1DD
UK
Tel: + 44 (0)1273 7272 68
Fax: + 44 (0)1273 7272 69
E-mail: sales@RotoVision.com

Distributed to the trade in the United States by:
Watson-Guptill Publications
1515 Broadway
New York, NY 10036
USA

ISBN 2-88046-374-2

This book was designed, edited and produced by
Hilton & Stanley
63 Greenham Road
London N10 1LN
UK

Design by David Stanley
Picture research by Anne-Marie Ehrlich

DTP in Great Britain by
Hilton & Stanley
Printed in Singapore

Production and separations in Singapore by ProVision Pte. Ltd.
Tel: + 65 334 7720
Fax: + 65 334 7721

Photographic credits
Front cover: Majken Kruse
Page 1: Jo Sprangers
Pages 2–3: John Freeman
Page 160: John Freeman
Back cover: Trevor Godfree

Contents

Family and religious events

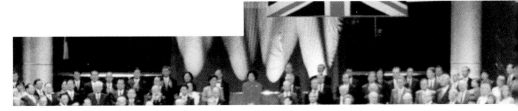

Political events and dignatories

3

Sporting events

4

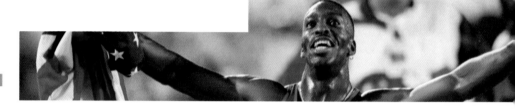

Portraits

5

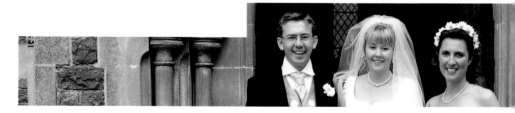

Weddings

Introduction

THE POWER OF PHOTOGRAPHY TO CAPTURE A FROZEN INSTANT OF TIME, to record in a split second images of people and events that signify something of importance to those depicted, as well as to the picture's audience, makes the camera a particularly invaluable tool when it comes to making a permanent record of a special occasion.

Special occasions come in all shapes and sizes. Some of these events are of such significance that they affect entire neighbourhoods – the visit of a dignitary to your children's school, perhaps, a major fund-raising event, or the return home of a local athlete after success at a national or an international competition. Other events may produce ripples of interest that spread much further afield, capturing the imagination of whole nations. The election of a new head of state falls into this category, but a less obvious event could be the type of international sporting competition that has the power to empty city streets as entire populations stay indoors to watch their home teams play on television. Other special occasions transcend national considerations and are of world-shaping importance. On an occasion such as this, just a single telling image can register in the imaginations of millions of people, shaping perceptions of what has occurred in a way that words alone could never do.

PHOTOGRAPHER:
John Freeman
CAMERA:
6 x 7cm
LENS:
140mm
FILM:
ISO 100
EXPOSURE:
Shutter held open on B-setting while the flash was fired twice
LIGHTING:
Accessory flash

▶

Don't be afraid to try an experimental approach to special occasions portraiture. For this birthday picture the photographer included both profiles of the subject in the same picture by exposing the same frame of film twice in a darkened studio. Between flashes, the subject moved from one seat to another, their positions having been carefully calculated to ensure that the two images would not overlap.

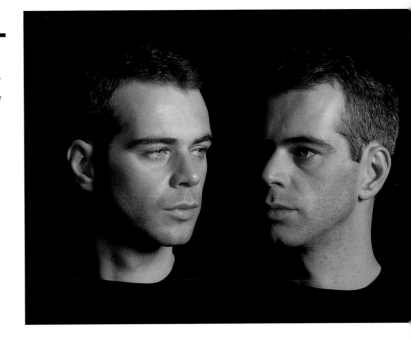

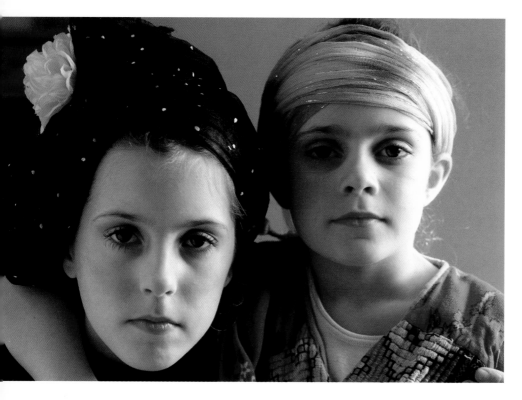

A fancy dress party for two sisters prompted this double portrait. The girls had just finished their costumes and make-up when the photographer, who had been commissioned to cover the afternoon's celebrations, took a quick shot of them in their bedroom.

PHOTOGRAPHER:
John Freeman
CAMERA:
35mm
LENS:
50mm
FILM:
ISO 64
EXPOSURE:
⅟₆₀ second at f5.6
LIGHTING:
Daylight only

Everyday events

For most of us most of the time, however, it is not the earth-shaking world events that are of primary concern. The special occasions that punctuate our daily lives are probably not likely to be of much interest to anybody outside our immediate circle of family and friends. But they are, for all that, important markers and most of us regard the photographs we have of them as precious mementoes. It could be, for example, that you want to commemorate an important anniversary by having a formal portrait taken, or it could be a family tradition to have portraits taken of your children each year on their birthdays. Other special occasions are more one-off in nature – graduation day, for example, victory at a flower show, winning a dance competition, the birth of a child, a christening, bar-mitzvah or some other religious milestone.

The family occasion that usually has most money spent on it in terms of photography is a wedding. Indeed, many photographers specialize in this area of activity and, once they have established a good client base, it becomes the mainstay of their businesses. You will not succeed as a wedding photographer, however, unless you do some proper basic research. Part of this is finding out the precise requirements of clients – when the coverage is to start – with the bride's preparations early in the morning, for example – when it is to finish – perhaps at the cutting of the cake at the reception after the ceremony – how many pictures are to be taken and of whom, the form of the picture portfolio, and so on. You will also need to find out in advance whether or not photography is permitted during the ceremony itself and, if it is, what to expect in terms of likely natural lighting levels. It is also a good idea to investigate potential backgrounds, settings and shooting angles, depending on the weather conditions on the actual

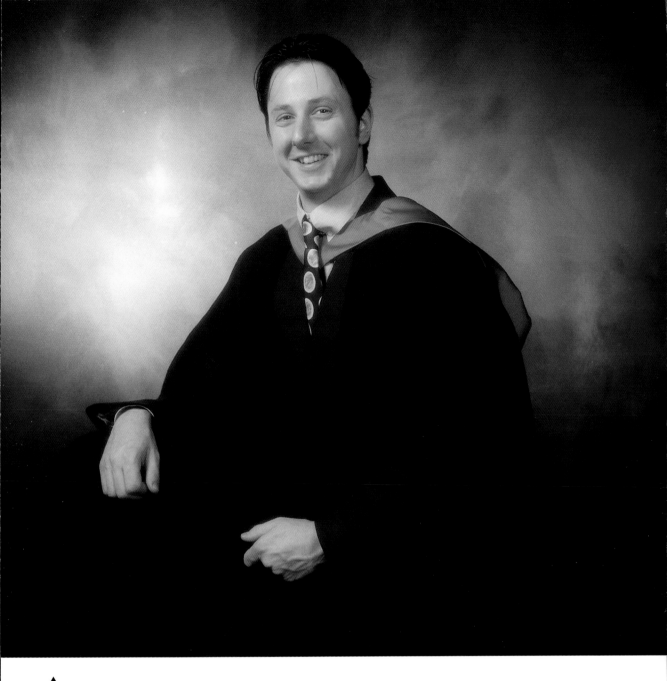

▲

Graduation day is a proud moment not only for the student but also for his or her entire family. Although, at the time, the subject may feel awkward sitting in the studio in a hired graduation gown, a portrait such as this is likely to become more and more appreciated as the years go by. The darkened edges to the frame produce a tunnel-like effect, which concentrates attention on the subject, and was achieved by using a stocking filter. Main and fill lights were used to illuminate the subject, while a separate light was used for the backdrop.

PHOTOGRAPHER: **Lesley Ann Fox**	EXPOSURE: **⅟₆₀ second at f8**
CAMERA: **6 x 6mm**	LIGHTING: **Studio flash x 3**
LENS: **80mm**	**(2 fitted with**
FILM: **ISO 160**	**reflective** **umbrellas)**

day. It's a good idea to have a fall-back position if, for example, rain or overcast spoils your plans for outdoor coverage. If your work is largely restricted to the surrounding district, you will soon build up a comprehensive local knowledge, and these preparations will not really take much of your time.

If you have been commissioned to photograph a wedding ceremony whose form and practices you are not familiar with, ask the couple, their parents or some other knowledgeable person to run you through the detail and sequence of events in advance so that you don't miss anything of importance.

Approaches

At major sporting, political or social events, it is only accredited press or freelance photographers who have the benefit of privileged access to the main arena of activity. But this is not necessarily a bar to effective photography. Often you can overcome the problem of being far back from the main action by finding a higher position from which to shoot. Just raising your camera height by a few feet can clear the foreground area of intervening heads or other obstructions. A long lens helps without doubt, but unless you have some effective means of steadying the camera any resulting pictures run the risk of being marred by camera shake. If lighting levels are high and/or you have fast film in the camera and a prime lens with a reasonably wide maximum aperture, then a teleconverter may be the answer. This device fits between the camera body and lens and magnifies a section of the image produced by the lens.

On the down side, the greater the magnification of the converter the greater the light loss overall, and so you could find yourself losing a couple of stops of lens speed and having to use an impossibly slow shutter setting to compensate. Teleconverters are made by some camera manufacturers for their own models and by independent manufacturers for a wide range of popular camera makes. If you are choosing a converter from an independent, make sure it is designed for your specific camera model, or you may find that you have lost some automatic features, such as through-the-lens metering or autofocus.

Another approach to this type of coverage is to turn your attention away from the action and concentrate instead on the crowds of people all around you. Look for interesting combinations of subjects or facial expressions, using a long lens to isolate them from their surroundings.

Moving to the other extreme, good use can be made of a wide-angle lens to frame shots that encompass masses of people and so convey the mood and atmosphere of the occasion that way.

In most situations, the types of special event that are likely to be recorded by a photographer are known about well in advance and can, therefore, be planned for. But planning in itself does not make for good photography. Even at a formal portrait session in a studio, the ability of the photographer to draw out from the subject some aspect of their character is of paramount importance. And, apart from the strictly technical considerations, the most important aspect of photography is knowing exactly when to press the shutter release. Choosing the precise moment when all the elements making up the image come together to create the perfect composition is key to the art of photography.

Equipment and accessories

The camera format most often used by studio-based photographers is one of the popular medium format types – 6 x 4.5cm, 6 x 6cm or 6 x 7cm. These cameras produce a larger negative (or positive slide image) than the type used nearly universally by amateur photographers and many professionals working on location – the 35mm camera. Generally speaking, the larger the original film image, the better the quality of the resulting print, since it requires less enlargement. The often relatively slow pace of a studio session also seems to favour the use of the larger format, since it tends to encourage a more considered approach to each shot. However, good-quality 35mm SLR cameras and lenses are capable of producing superb results, and they come into their own when hand-held shooting is necessary, for 'grabbed', candid-type shots, or when the session is perhaps unpredictable and the photographer needs to respond very quickly to the changing situation.

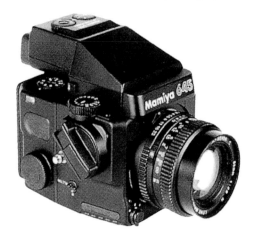

This is the smallest of the medium format cameras and produces rectangular-shaped negatives or slides measuring 6 x 4.5cm.

Medium format cameras

This format, of which there are many variations, is based on 120 or 220 rollfilm. This type of film has a paper backing to protect the emulsion and the sprocket holes familiar to users of 35mm film are missing. The number of exposures per roll of film you can typically expect from the three most popular medium format cameras are:

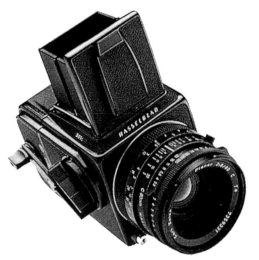

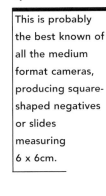

This is probably the best known of all the medium format cameras, producing square-shaped negatives or slides measuring 6 x 6cm.

Camera type	120 rollfilm	220 rollfilm
6 x 4.5cm	15	30
6 x 6cm	12	24
6 x 7cm	10	20

The advantage most photographers see in using medium format cameras is that the large negative size – in relation to the 35mm format – produces prints of excellent quality, especially when big

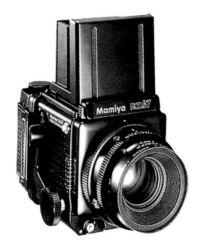

◄ This is the largest of the popular medium format cameras, producing rectangular negatives or slides measuring 6 x 7cm. (A 6 x 9cm format is also available but is not commonly used.)

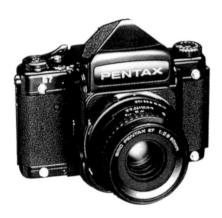

◄ This type of 6 x 7cm medium format camera looks much like a scaled-up 35mm camera, and many photographers find the layout of its controls easier to use.

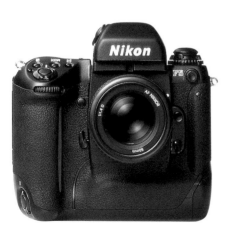

◄ This truly professional and versatile 35mm system camera, has an 8 frame-per-second motor drive, a choice of different metering systems; exposure and AF locks; exposure compensation; and a choice of aperture- or shutter-priority, fully automatic or fully manual exposure options.

enlargements are called for, and that this fact alone outweighs any other considerations. The major disadvantages with this format are that, again in relation to the 35mm format, the cameras are often heavy and slightly awkward to use; they are often not highly automated (although this can often be a distinct advantage); the camera bodies and lenses are expensive to buy; and you get fewer exposures per roll of film.

35mm single lens reflex cameras (SLRs)

The standard of the best-quality lenses produced for the 35mm SLR are so good today that for average-sized portrait enlargements of, say, 20 x 25cm (8 x 10in) results are superb.

The 35mm format is the best supported of all the formats, due largely to its popularity with amateur photographers. There are at least six major 35mm manufacturers, each making an extensive range of camera bodies, lenses, dedicated flash units, and specialized as well as more general accessories. Cameras within each range include fully manual and fully automatic models. Lenses and accessories made by independent companies are also readily available.

Compared with medium format cameras, 35mm SLRs are lightweight, easy to use, generally feature a high degree of automation, and are extremely flexible working tools. For big enlargements, however, medium format cameras have a distinct edge in terms of picture quality.

All 35mm SLRs use the same size of film cassette, containing either 24 or 36 shots, in colour or black and white, positive or negative. Again because of this format's popularity, the range of

films available is more extensive than for any other camera.

Lenses

When buying lenses, don't compromise on quality. No matter how good the camera body is, a poor-quality lens will take a poor-quality picture, and this will become all too apparent when enlargements are made. Always buy the very best you can afford.

One factor that adds to the cost of a lens is the widest maximum aperture it offers. Every time you change the aperture to the next smallest number – from f5.6 to f4, for example – you double the amount of light passing through the lens. This means that you can shoot in progressively lower light levels without having to resort to supplementary lighting such as flash. At very wide apertures, however, the lens needs a high degree of optical precision in order to produce images with minimal distortion, especially toward the edges of the frame. Thus, lenses offering an aperture of f1.4 cost much more than lenses with a maximum aperture of f2.8.

At a 'typical' outdoor photographic session, you may need lenses ranging from wide-angle (for showing the environment as well as the subject, or for large-group portraits) through to moderate telephoto (to allow you to enlarge the size of the subject and hence alter the proportions of subject and setting). For 35mm cameras, the most generally useful lenses are a 28 or 35mm wide-angle, a 50mm standard, and about a 90 to 135mm telephoto.

As an alternative, you could consider using a combination of zoom lenses – for example, a 28–70mm zoom and another covering the range 70–210mm. In this way you have in just two lenses the extremes you are likely to use, plus all the intermediate settings you need to 'fine-tune' framing and composition.

There is markedly less choice of focal lengths for users of medium format cameras. Lenses are also larger, heavier and more expensive to buy, but the same wide-angle, standard and telephoto lens categories apply. There

is also a limited range of medium format zooms to choose from.

Accessory flash

The most convenient artificial light source when shooting on location is, without doubt, the accessory flashgun. Different units produce a wide range of light outputs, so choose the one that is most suitable for the type of area you need to illuminate. Remember that flash used outdoors will not have the same effective range as it does indoors.

Tilt-and-swivel flash heads give you the option of bouncing light off any convenient wall or ceiling when you are working indoors. In this way, your subject will be illuminated by reflected light, which produces a kinder, more flattering effect. You need to bear in mind, however, that some of the power of the flash will be absorbed by any of these intervening surfaces.

The spread of light leaving the flash head is not the same for all flash units. Most are suitable for the angle of view of moderate wide-angle, normal, and moderate telephoto lenses. However, if you are using a lens with a more extreme focal length, you may find the light coverage inadequate. Some flash units can be adjusted to suit the angle of view of a range of focal lengths, or adaptors can be fitted to alter the spread of light.

Long-life lighting

One of the problems of using accessory flash is the number of times the flash will fire before the batteries are exhausted. There is also the problem of recycling speed – the time it takes for the batteries to build up sufficient power in order to fire once more. With ordinary batteries, after as few as 30 firings recycling time may be so long that you need to change batteries (the fresher the batteries, the faster the recycling time). This is not only expensive, it is also time consuming. The solution to these problems is to use a battery pack. With some types of pack, when fully charged you can expect as many as 4,500 firings and a flash recycling time as low as ¼ second – which is fast enough to use with a camera and motor drive. These figures do, of course, assume optimum conditions, such as photographing a nearby subject, with plenty of reflective surfaces nearby to return the light, and with the flashgun set to automatic.

Studio flash

For the studio-based portrait photographer, the most widely used light source is studio flash. Working

▼

'Hammer-head' style accessory flash units are capable of producing high light levels and so are often used with heavy-duty battery packs. Always choose a model with a tilt-and-swivel head facility for a variety of lighting effects.

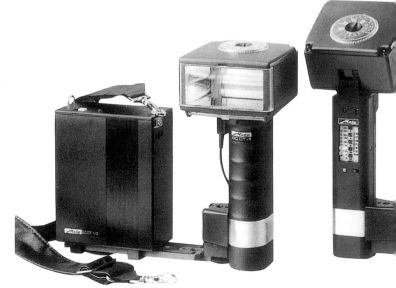

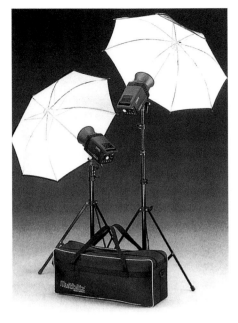

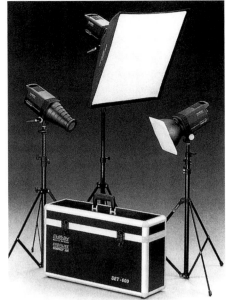

▲

These modern studio flash units have been designed with location work in mind. This set-up, which comprises two lighting heads, reflective umbrellas, and lighting stands, packs away into the flexible carrying bag illustrated.

▲

For a wider range of lighting effects, this set-up has three lighting heads, with add-on softbox, snoot and scrim, and three lighting stands. It all packs away into the case illustrated, which would easily fit into the boot or back seat of a car.

either directly from the mains or via an intervening control box/power pack, recycling time is virtually instantaneous and there is no upper limit on the number of flashes. However, as long as you have an appropriate power source, such as a heavy-duty car battery, there is no reason why this type of flash unit cannot be used when you are shooting away from the studio on location.

A range of different lighting heads, filters, and attachments can be used to create virtually any lighting style or effect, and the colour temperature of the flash output matches that of average daylight, so the two can be mixed in the same shot without any colour cast problems occurring.

When more than one lighting head is in use, as long as one light is linked to the camera's shutter, synchronization cables can be eliminated by attaching slave units to the other heads. Another advantage of flash is that it produces virtually no heat – this is a real problem when using studio tungsten lighting. To overcome the problem of predicting precisely where subject shadows and highlights will occur, which cannot be seen normally because the burst of light from the flash is so brief, each flash head should be fitted with a 'modelling light'. The output from these lights is low and won't affect exposure, but it is sufficient for you to see the overall lighting effect with a good degree of accuracy.

FAMILY & RELIGIOUS EVENTS

Street festivals

THE MAJOR ADVANTAGE YOU HAVE WHEN PHOTOGRAPHING EVENTS such as street festivals is that they tend to happen at yearly intervals and on a date that is well publicized in advance – and this gives you plenty of time to prepare.

The special occasion illustrated here and on the following pages is London's Notting Hill Carnival, which is the largest celebration of Caribbean culture held anywhere in Europe, taking place over the three-day August bank holiday weekend every year. Because of the size of the carnival – with its steel bands, floats, dancers, musicians, performers, street vendors and food stalls – and the narrowness of the streets around the innercity suburb of Notting Hill, the festival meanders over a large area, giving photographers plenty of opportunities to find a prime location for at least some of the activities. Also, because of the crush of people there, and the proliferation of cameras, nobody will really take any notice of what you are doing.

In situations such as street festivals, you should take only the bare minimum of equipment – a camera bag full of lenses and accessories is heavy and is likely to get in the way just when you want your hands free to grab a quick shot. Ideally, take one camera body and a zoom lens in the 28–80mm zoom range (for the 35mm-format). The wide-angle end of this zoom is ideal when you cannot move very far back from your subject yet you still want to take in a broad sweep of the scene; the moderate telephoto end of the range will help you to isolate individual subjects or small scenes. To protect the front element of the lens from stray finger marks, dust or grit, leave a colourless UV filter on at all times. A lightweight jacket with deep pockets is ideal for carrying spare rolls of film and any accessories you habitually use

PHOTOGRAPHER:
Tim Ridley
CAMERA:
35mm
LENS:
**28–80mm zoom
(set at 80mm)**
FILM:
ISO 100
EXPOSURE:
⅟₆₀ second at f5.6
LIGHTING:
Daylight only

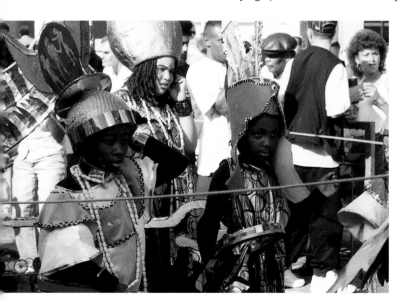

A moderate telephoto focal length helps you to isolate small scenes from the general activity all around. When contrast is high, with bright highlights and shadows adjacent to each other, it is often better to time your shot to catch your subjects in the shade – overbright sunlight tends to bleach colour, as you can see in the background figures here.

People attending the carnival are there to have fun and enjoy themselves and will almost certainly not mind you taking their photograph – they are more likely, as here, to play to the camera if, that is, they notice you at all in all the confusion and noise.

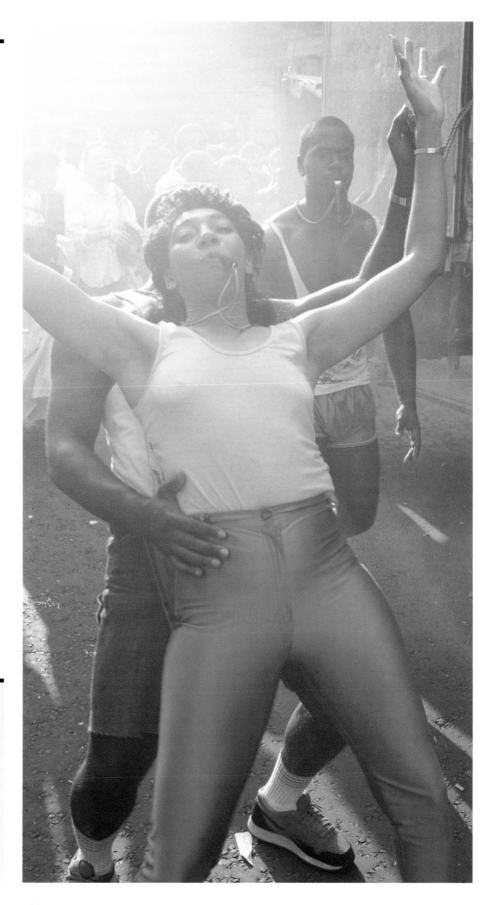

PHOTOGRAPHER:
Tim Ridley
CAMERA:
35mm
LENS:
28–80mm zoom (set at 50mm)
FILM:
ISO 100
EXPOSURE:
½₅₀ second at f5.6
LIGHTING:
Daylight only

It is worth bearing in mind that at the Notting Hill Carnival the first day of the three-day event is traditionally nominated as children's day. Here, the photographer came away from the main route of the carnival processions and happened on one of the mustering areas where the young performers wait for their turn to 'take to the streets'.

PHOTOGRAPHER:
Tim Ridley
CAMERA:
35mm
LENS:
28–80mm zoom (set at 80mm)
FILM:
ISO 100
EXPOSURE:
$\frac{1}{125}$ second at f5.6
LIGHTING:
Daylight only

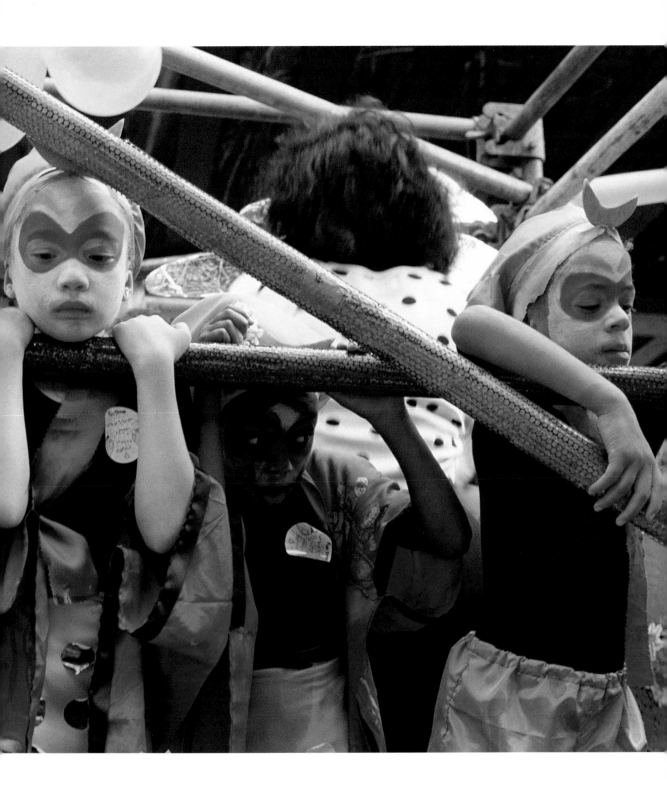

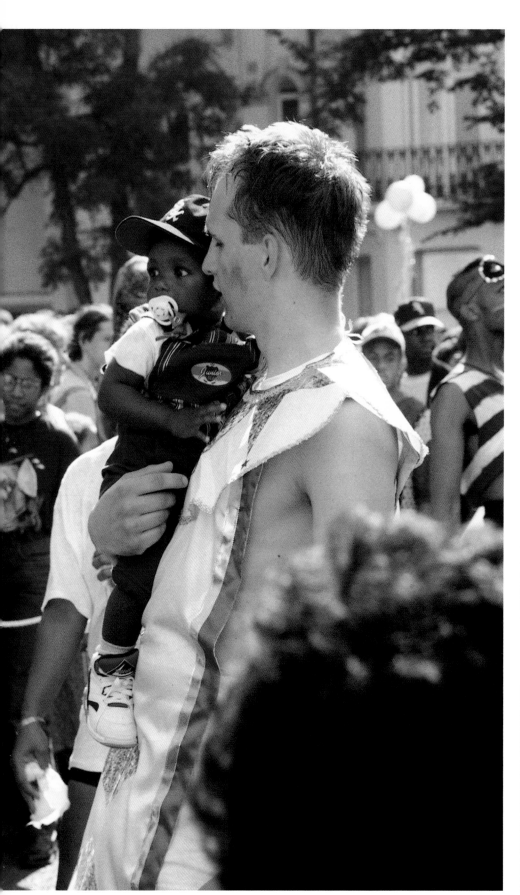

Don't become so fixated on the organized events and activities that you fail to notice the photographic potential in the bystanders all around you. A good idea is to sweep the scene with your camera, allowing different groups of people or individual characters to jump on to the focusing screen. This way, you are less likely to become distracted by anything on the periphery of your vision, and the hard, defined edges of the focusing screen will help you to concentrate on small, specific areas of the scene at a time.

PHOTOGRAPHER:
Tim Ridley
CAMERA:
35mm
LENS:
28–80mm zoom (set at 80mm)
FILM:
ISO 100
EXPOSURE:
1⁄60 second at f5.6
LIGHTING:
Daylight only

One of the key features of the Notting Hill Carnival is the elaborately flamboyant costumes of the revellers. Here, the photographer tracked this one dancer with his camera lens, keeping him constantly in focus, waiting until he moved into a patch of shade before tripping the shutter release. When the costume was seen in full sunshine, its vibrant red and the contrasting yellows and black appeared desaturated and so made far less impact.

PHOTOGRAPHER:
Tim Ridley
CAMERA:
35mm
LENS:
28–80mm zoom (set at 80mm)
FILM:
ISO 100
EXPOSURE:
1/60 second at f5.6
LIGHTING:
Daylight only

New babies

THE ARRIVAL OF A NEW BABY, OR THE CHRISTENING CEREMONY that can follow soon afterwards, is such a special occasion for families that they invariably want a photographic record taken – not only for themselves but also copies of prints to send out to family and friends.

If the birth is a hospital delivery, you will probably find that the attitude of authorities to the presence of photographers on the maternity ward is much more relaxed today than it was even a few years ago. And as long as you work quickly, keep equipment to a minimum and do not interfere with the routine of the ward or disturb any of the other patients or their families there will almost certainly be no objections. If possible, take advantage of any daylight coming in through windows – natural light invariably produces a better atmosphere than artificial illumination. If the daylight is overly contrasty and cannot be modified (with blinds, for instance), then use a simple reflector on the shadow side of the subject to brighten the shadows and so even out exposure overall. If natural light levels are impossibly low, supplementary lighting from an accessory flashgun is your most convenient option. Diffuse the light by taping a piece of tracing paper over the flash tube (or use a piece of white cloth, such as a handkerchief, for a more diffused effect) or bounce the light from the ceiling or nearby wall. Used direct, the output from a flashgun is often far too harsh and unflattering and so is best avoided.

If the birth is a home delivery, you may have the option of a more elaborate lighting scheme, perhaps substituting a portable studio flash unit (fitted with a softbox or reflective umbrella) for the accessory flashgun.

PHOTOGRAPHER:
Janine Wiedel
CAMERA:
35mm
LENS:
90mm
FILM:
ISO 400
EXPOSURE:
⅟₆₀ second at f4.5
LIGHTING:
Daylight only

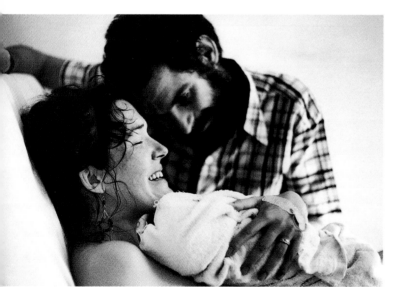

◀

Although the newborn baby cannot actually be seen in this shot, the photographer has, nevertheless, captured the very essence of the occasion. The mother's face is a mixture of tiredness and joy and the father, one hand gently resting on the swaddled bundle we know to be the baby, has his arm protectively around the pillow. The framing is tight and the composition thoughtful, and all extraneous information has been stripped away to leave only what is truly important to the picture.

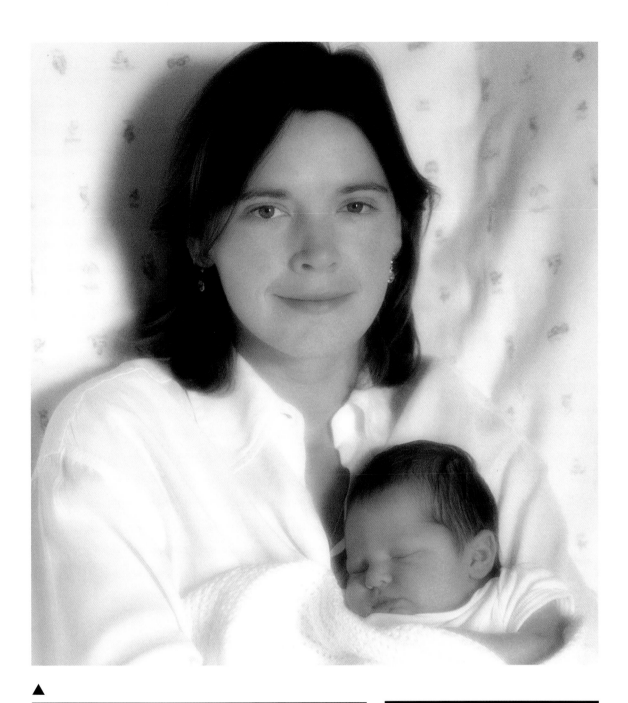

▲

Parents wanting commissioned photographs taken of their newborn babies often wait a few days after the birth, until mother and child are home from the hospital. Many people feel more relaxed, happy and attractive in their own home surroundings, and the calmer atmosphere away from the sterile routine of a hospital ward will be transmitted to the infant as well. The photographic session that produced the picture here lasted about 40 minutes, and despite the frequent bursts of light from a studio flash unit, the four-day-old baby slept throughout the whole ordeal.

PHOTOGRAPHER: **Majken Kruse**	EXPOSURE: **⅟₆₀ second at f8**
CAMERA: **6 x 6cm**	LIGHTING: **Daylight and studio flash (fitted with a softbox)**
LENS: **80mm (plus soft-focus filter)**	
FILM: **ISO 50**	

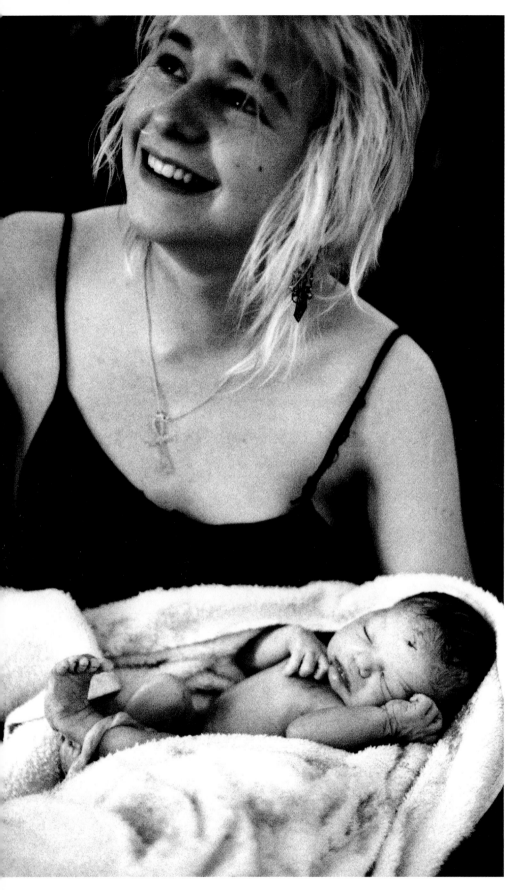

Having been invited to attend and record the actual birth, the photographer adopted a candid approach to the assignment, keeping out of the way as much as possible and picking off shots as the opportunities presented themselves. With so much going on, the presence of the photographer was the last thing on the mother's mind, and she caught this wonderfully natural scene as the mother held the baby up proudly just moments after the delivery, the umbilical cord still attached.

PHOTOGRAPHER:
Janine Wiedel
CAMERA:
35mm
LENS:
35mm
FILM:
ISO 400
EXPOSURE:
¹⁄₆₀ second at f5.6
LIGHTING:
Daylight only

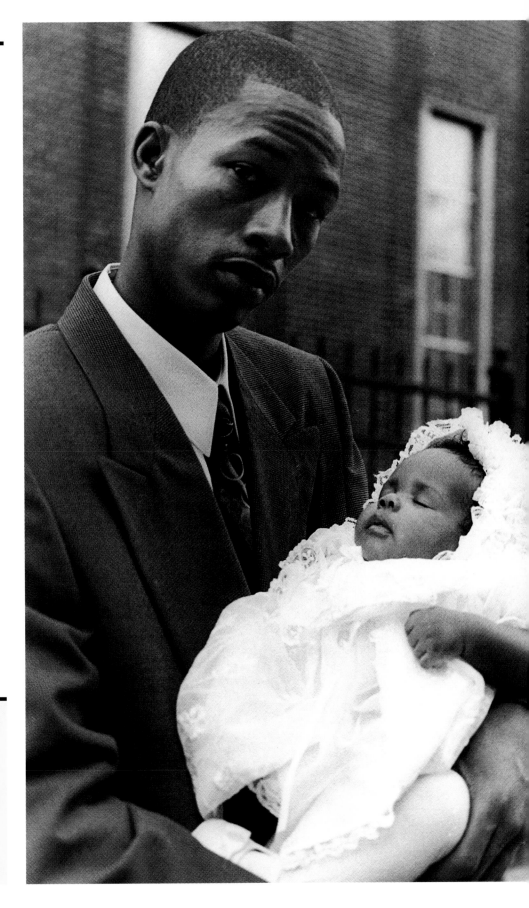

Christenings are very special occasions that are invariably photographically recorded as a precious part of a family's history. Bear in mind that christening gowns can be important family heirlooms, handed down and used by generation after generation. If so, then make sure that it features prominently in at least some of the shots. The setting selected by the photographer for this photograph was essentially dark toned and angular, thus ensuring that the baby's soft, rounded shape and white gown contrasted strongly with the surroundings.

PHOTOGRAPHER:
Linda Sole
CAMERA:
35mm
LENS:
50mm
FILM:
ISO 400
EXPOSURE:
½₅₀ second at f4
LIGHTING:
Daylight only

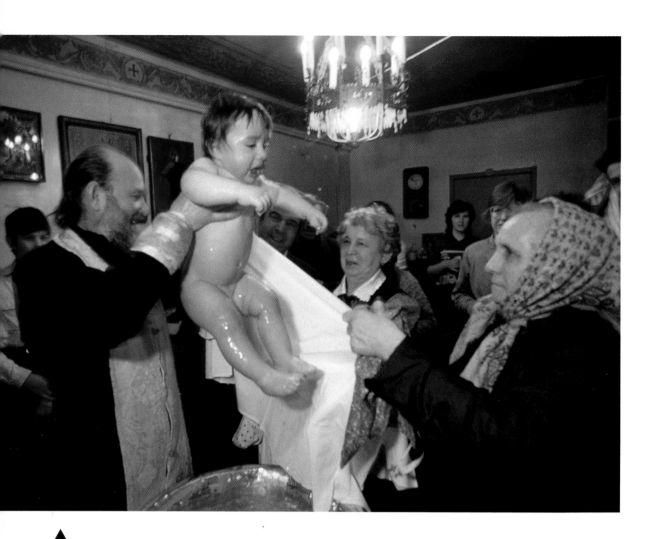

▲

Looking shocked and bewildered, the baby is held aloft by the priest, having just been entirely immersed as part of her baptism ceremony. Gathered around in her parents' Moscow apartment are close friends and family and, in the foreground, the grandmother looks tense as she prepares to wrap the infant in her christening gown once more. Windows, out of view of the camera, delivered some daylight to the scene, but this had to be supplemented by a domestic tungsten ceiling light, the illumination from which has produced the warm orange colour cast you can see.

PHOTOGRAPHER:
Chip Hires/Frank Spooner Pictures/Gamma
CAMERA:
35mm
LENS:
28mm
FILM:
ISO 200
EXPOSURE:
1/25 second at f5.6
LIGHTING:
Daylight and domestic tungsten

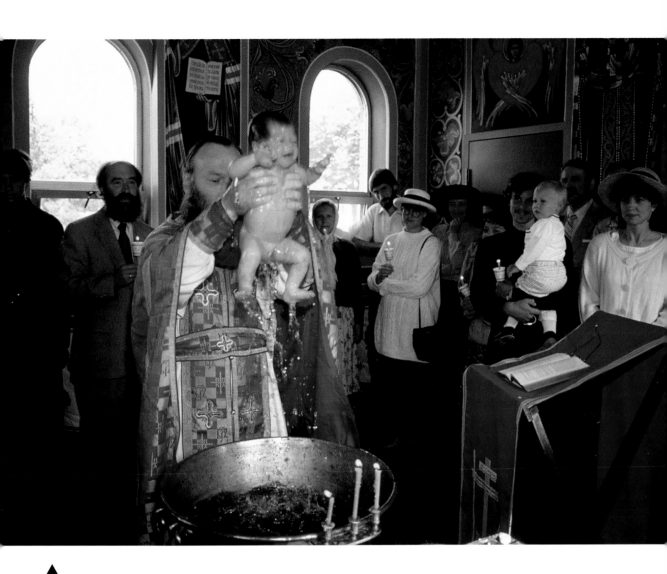

▲

The arrangement of windows in this church meant that all the available daylight was coming from behind the priest and the newly baptized infant. Had the photographer adjusted exposure to compensate for this, an impossibly slow shutter speed would have been required and all the figures illuminated by the background windows would have been massively overexposed. With the church ceiling being so high and the walls so distant, it was not possible to use them as surfaces from which to bounce the light from the flash, so it had to be used direct.

PHOTOGRAPHER:
Figaro/Frank Spooner Pictures/Gamma
CAMERA:
35mm
LENS:
50mm
FILM:
ISO 200
EXPOSURE:
1/60 second at f8
LIGHTING:
Daylight and accessory flash

Lighting, framing, composition and exposure are all the elements of this Cuban spiritual revival baptism ceremony that have come together in perfect harmony. The warmth of the afternoon light filtering through coloured curtains at the windows and spread by the smoky atmosphere inside from incense burners produces an illumination that is almost theatrical in its effect, while the photographer has timed the shot to capture every telling expression on the faces of the parents, priest and baby. And the angle of the mother's body as she holds the infant creates a dynamism that makes the scene look as if it is about to burst into movement.

PHOTOGRAPHER:
Ferry/Liaison/Frank Spooner Pictures/Gamma
CAMERA:
35mm
LENS:
28mm
FILM:
ISO 100
EXPOSURE:
$\frac{1}{125}$ second at f4
LIGHTING:
Daylight only

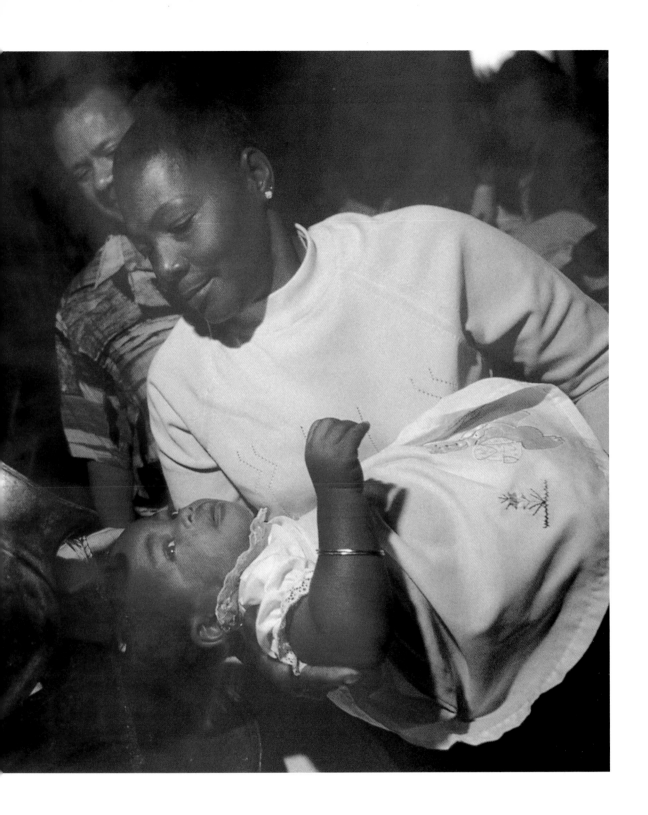

Dressing for the occasion

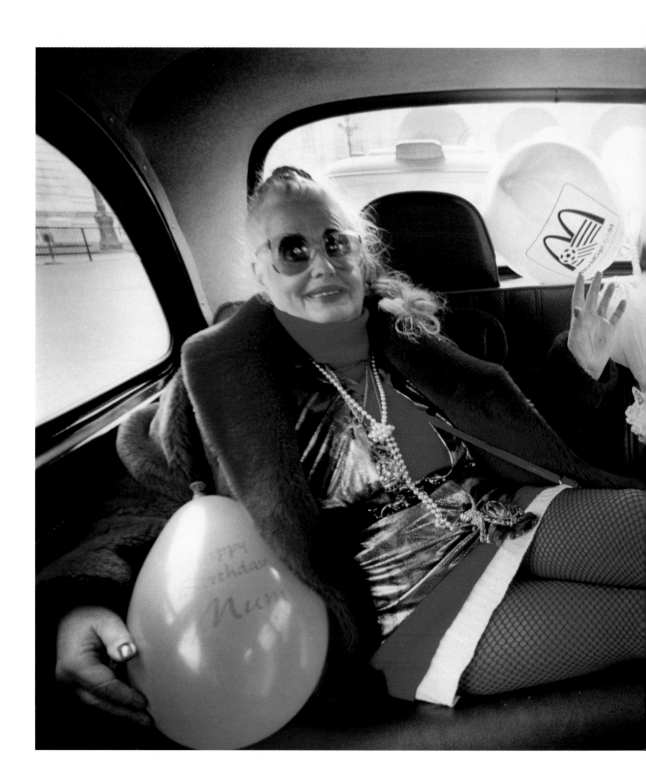

THERE ARE SOME SPECIAL FAMILY EVENTS, such as a mother's birthday, which demand that the subject really dresses appropriately for the occasion. Entering into the fun of the day, one in which her children had planned a non-stop series of activities, this celebrant made sure that even a casual observer would be left in no doubt that she was the star for the occasion

Starting with a champagne breakfast and a morning of sightseeing, lunch was planned before an early show and then dinner – and for the entire day her transport was to be one of London's famous black cabs.

◀

Lounging on the bench seat in the back of a London black cab, this mother was celebrating her birthday with a real sense of style – gold glitter boots and red fishnet tights set off by a gold top and strings of knotted pearls. And don't forget the lacy parasol and balloons. The picture was taken close-up using a wide-angle lens from the seat opposite. These taxis have large windows on all sides of the passenger compartment, making even lighting less of a problem that it might be in another type of vehicle. No artificial illumination was necessary for the shot, but the photographer waited for the taxi to be brought to a stop by the traffic before taking the picture. Otherwise, vibrations transmitted from the road surface and the engine would have forced her to use a very brief shutter speed, one requiring too wide an aperture to compensate.

PHOTOGRAPHER:
Linda Sole
CAMERA:
35mm
LENS:
28mm
FILM:
ISO 200
EXPOSURE:
1/60 second at f8
LIGHTING:
Daylight only

Religious observance

For millions of people around the world, life is punctuated by religious observance of one type of another. In some religions, some of the most important observances can be termed rites of passage, when, for example, individuals change their status from children to adults and are then expected to take on responsibility for their own religious observance. At such times, families may commission a formal portrait or more informal, candid coverage of the event. Always check in advance that photography is allowed, since it is not uncommon to find a prohibition on photographing at least some aspects of religious ceremonies.

Most religions have particularly significant, or holy, sites that believers may wish to visit regularly; or if they live far away and travel is not easy, then at least once during their lifetimes. Such places may be the birthplace of the

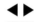

In the Jewish religion, boys on reaching the age of about 13 years undergo a religious ceremony known as bar mitzvah, after which time, in the eyes of the religion, they have achieved adult status and are essentially responsible for their own religious observances. After the ceremony, normally conducted in the synagogue but it can be held in the home or at a holy site, a party is usually thrown for family and friends. This rite of passage is of particular significance in the Jewish faith and it is not unusual for the bar mitzvah boy to have a formal portrait taken. To achieve this lighting effect, the photographer used two studio flash lighting units. The one to the left of the camera was fitted with a softbox; the one to the right of the camera was used direct. The boy was placed well forward of the black background paper so that any light spilling past him would not produce any unwanted grey tones.

EQUIPMENT REQUIREMENTS

The type of equipment you need depends on the circumstances. For example, during a religious service, assuming that photography is allowed at all, a compact or rangefinder type camera is often quieter in operation than an SLR – 35mm or medium format – and will therefore cause less disturbance and draw less attention to itself. If you are using an SLR of some type, sound-dampening blimps are available. These fit right around the camera, leaving an opening for the lens, and allow you reasonably unhindered access to relevant controls. It is still a good idea, however, to turn off any alarm or warning signals or beeps if your camera offers you this option.

Flash is often prohibited – it disturbs worshippers and if old or valuable paintings or painted wood or walls are present, it is possible that the intense burst of light may damage the surface of these. Using modern fast lenses and the types of super-fast films that are now available, lighting would have to be extraordinarily dim for photography to be impossible. However, you may find yourself working with whatever available light is present, so you should expect colour casts of some description, especially on slide film. These colour casts, rather than being a problem, may well add to the atmosphere of your pictures.

If slow shutter speeds are called for, look for a convenient surface, such as a low wall or the back of a seat, on which to rest the camera. A tripod is obviously an ideal camera support, but, again, it is not unusual for these to be banned from religious buildings. A monopod, however, may be allowed, and these offer a good degree of camera-steadying support if they are properly braced.

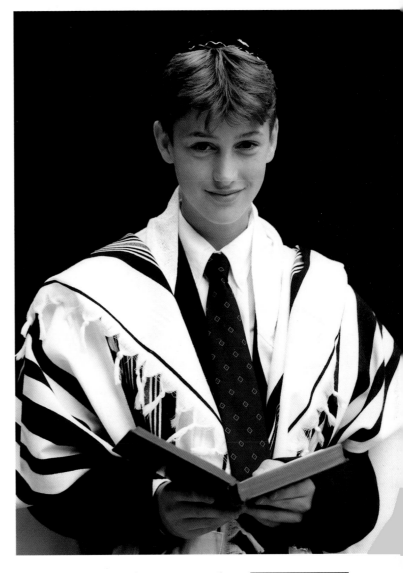

religion or the place where a person of importance in the religion died, or it may be where a particularly important temple, church, mosque or synagogue is located. Indeed, in some religions, visiting such a site at least once is an obligation. A well-conceived photograph can become a treasured family icon.

If you are taking candid pictures of worshippers, especially of specific individuals, you need to be sensitive to the cultural norms of the society, or simply to the preferences and reactions of individuals. If you can see that the presence of the camera is unwelcome then it is best to withdraw.

PHOTOGRAPHER:
Majken Kruse
CAMERA:
6 x 4.5cm
LENS:
80mm
FILM:
ISO 100
EXPOSURE:
¹⁄₆₀ second at f11
LIGHTING:
Studio flash x 2 (1 fitted with a softbox)

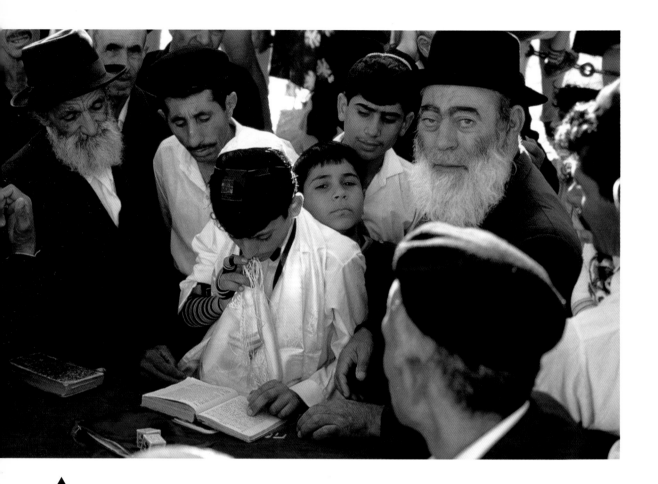

▲

One of the holiest sites in the Jewish
religion is the Wailing Wall in Jerusalem
and thus is an appropriate place to
conduct a bar mitzvah ceremony. The crush
of worshippers is usually so great at this
particular spot that you need to get in
close with a wide-angle lens if the subjects
are to have any impact.

PHOTOGRAPHER:
**Harvey Lloyd/Frank
Spooner
Pictures/Gamma**

CAMERA:
35mm

LENS:
28mm

FILM:
ISO 20

EXPOSURE:
1/125 second at f8

LIGHTING:
Daylight only

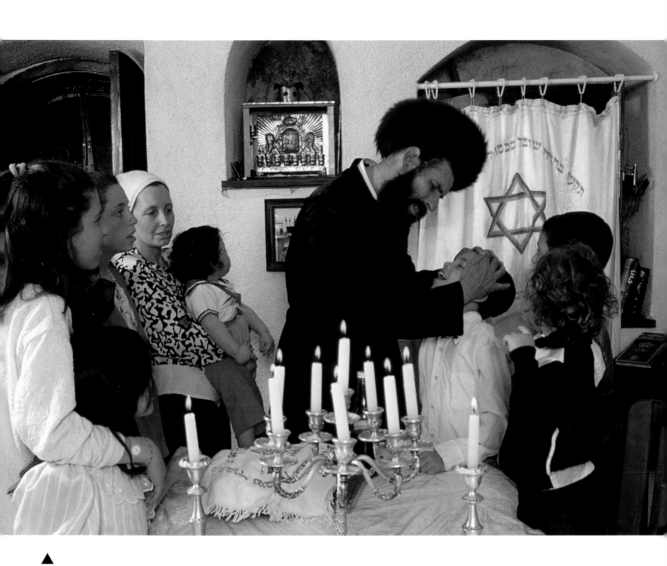

▲

The religious symbols in this ultra-orthodox Jewish home and the style of dress are so colourful that the resulting image has extra interest as the eye explores the unfamiliar. The lit candles cast a homely glow over the table, but this religious observance was conducted while the sunlight coming through the window was sufficient to illuminate the room.

PHOTOGRAPHER:
Baitel/Frank Spooner Pictures/Gamma
CAMERA:
35mm
LENS:
35mm
FILM:
ISO 400
EXPOSURE:
⅟₆₀ second at f8
LIGHTING:
Daylight only

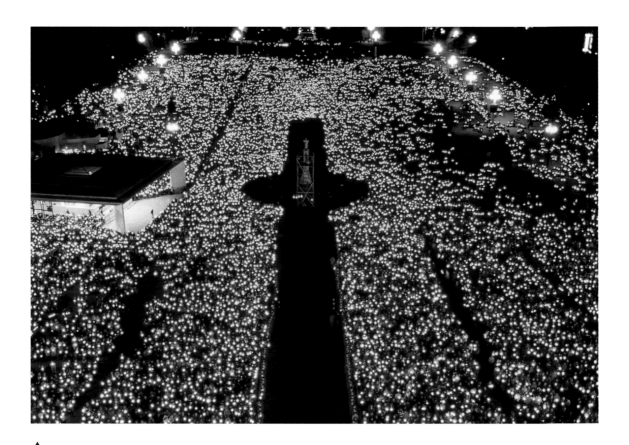

This candle-lit parade at the shrine to Our Lady of Fatima, Portugal, is moving due to its sheer scale, as tens of thousands of believers come together in vigil and communal prayer. Colour casts are pronounced throughout the scene – from the green of the fluorescent light to the warm-orange of the candle flames – but these only add to the appeal of the image.

PHOTOGRAPHER:
Gaillarde/Frank Spooner Pictures/Gamma
CAMERA:
35mm
LENS:
19mm
FILM:
ISO 200
EXPOSURE:
1 second at f5.6
LIGHTING:
Mixed available light

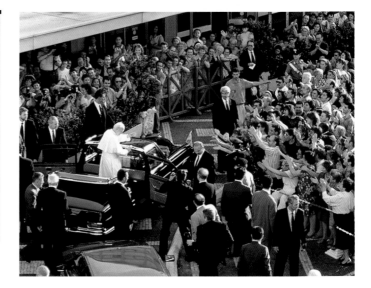

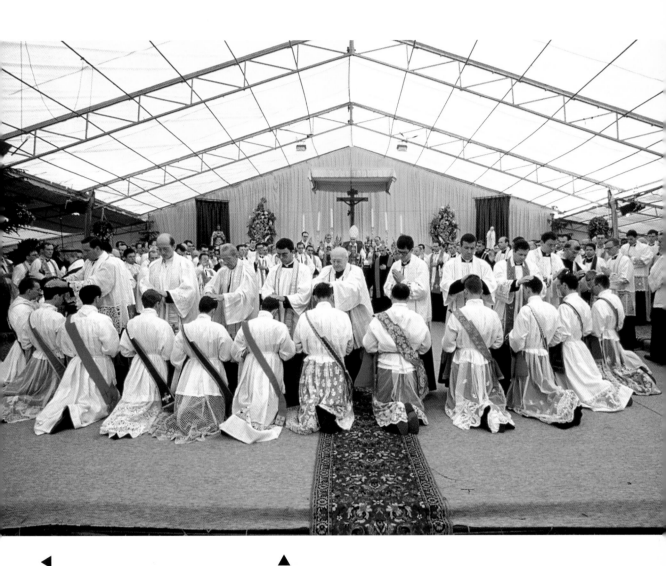

An opportunity to come close to the head of the Catholic Church – here, the appearance of Pope John Paul II – is always a special occasion for believers, especially when it is in Rome, where the population is almost entirely Catholic. A sign of the times is the presence of the dark-suited, ever-alert security personnel ensuring the personal safety of the pontiff.

An unusual site recorded by a photographer in Switzerland is this of an archbishop conducting a mass ordination of priests. Light levels in the church were high, but all of it was filtered through the translucent ceiling panels making up the roof, which accounts for the particular lighting effect.

PHOTOGRAPHER:
Anticoli-Musca/Frank Spooner Pictures/Gamma
CAMERA:
35mm
LENS:
50mm
FILM:
ISO 200
EXPOSURE:
½₅₀ second at f11
LIGHTING:
Daylight only

PHOTOGRAPHER:
Alain Morvan/Frank Spooner Pictures/Gamma
CAMERA:
35mm
LENS:
28mm
FILM:
ISO 100
EXPOSURE:
⅟₆₀ second at f8
LIGHTING:
Daylight only

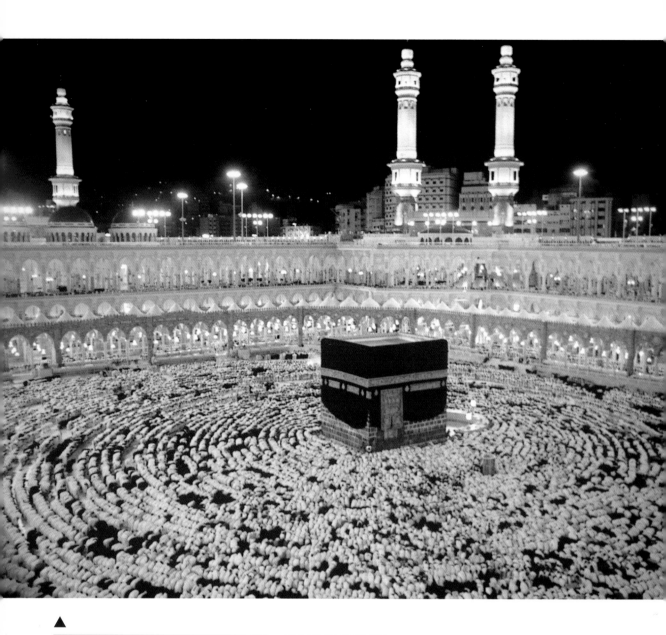

▲

For religious Muslims a pilgrimage to
Mecca in Saudi Arabia at least once in
their lifetime is an obligation – one that
millions of believers discharge each year.
Even with the benefit of an extreme wide-
angle lens, the angle of view was
insufficient to encompass the enormous
size of the Great Mosque. Mecca is the
holiest city of Islam and the Great Mosque
is the holiest site within it, so the
significance of this place is enormous. The
building in the courtyard is called the
Kaaba, which contains the Black Stone,
believed by Muslims to have been sent
down from heaven by Allah.

PHOTOGRAPHER:
**Frank Spooner
Pictures/Gamma**
CAMERA:
35mm
LENS:
17mm
FILM:
ISO 200
EXPOSURE:
½ second at f2.8
LIGHTING:
**Mixed available
light**

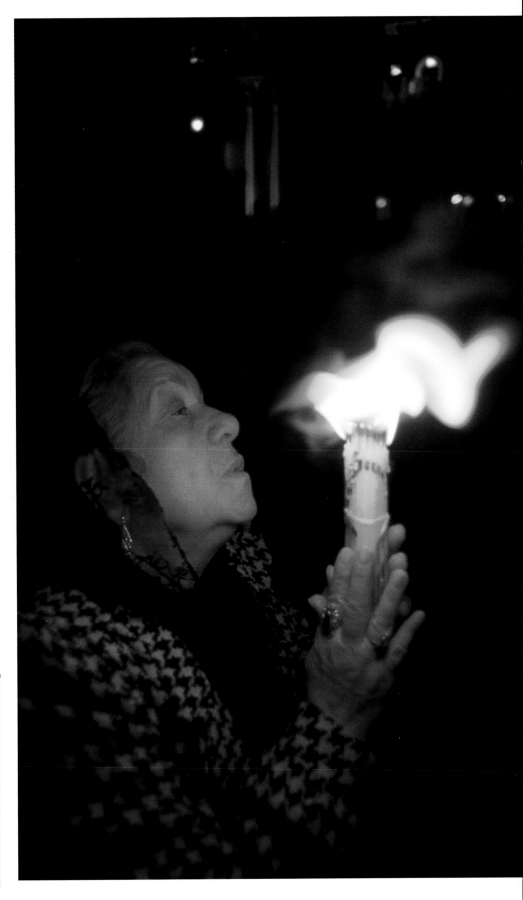

Individual portraits of worshippers always need to be handled with sensitivity to avoid disturbing people at prayer. For some, religious observation is intensely private, while for others it is a public devotion. Here, in the Church of the Holy Sepulchre in Jerusalem – itself a holy city for Jews, Christians and Muslims alike – the photographer has captured perfectly the devotion of this woman visiting the church during the annual Easter pilgrimage. The light thrown by the flaming torch was localized and the photographer had to time the shot, waiting until the woman's pro-file was evenly lit.

PHOTOGRAPHER:
Yurman/Frank Spooner Pictures/ Gamma
CAMERA:
35mm
LENS:
80mm
FILM:
ISO 400
EXPOSURE:
½ second at f4
LIGHTING:
Torch light

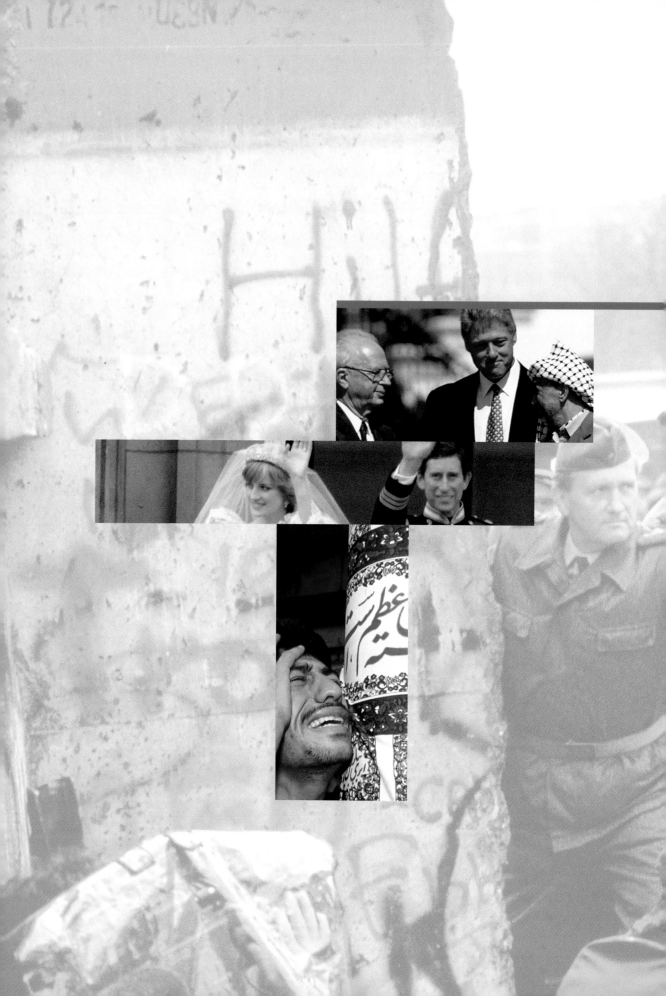

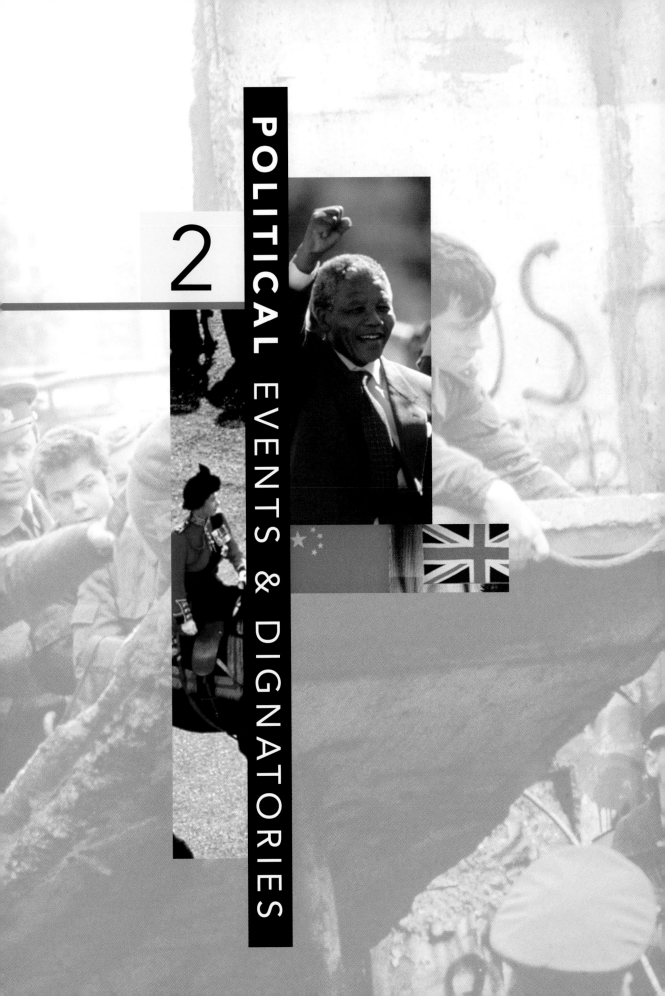

POLITICAL EVENTS & DIGNATORIES

Emotional extremes

PHOTOGRAPHER:
De Keerle/Frank Spooner Pictures/Gamma
CAMERA:
35mm
LENS:
28mm
FILM:
ISO 200
EXPOSURE:
⅟₂₅ second at f8
LIGHTING:
Mixed available light and diffused accessory flash

THE EXPRESSION OF JOY OR GRIEF VARIES FROM CULTURE TO CULTURE. In some, the expression of extreme emotion is an intensely private affair, while in others the public demonstration of emotion is the normal response and, depending on the situation, can be a part of the celebration or of the healing process. In general, take your lead from the culture you are photographing in and try above all else to be sensitive to the conventions of that place.

The intrusion of the camera into people's lives – those of ordinary people as well as those of celebrities or national figures – can sometimes be controversial. At times of great joy, there will usually be no objection to the presence of the camera, whether it is invited or otherwise. However, when the emotions being expressed are those of despair or great sadness, the decision whether or not to photograph those involved can be far harder to make. There are no rules governing a photographer's behaviour in this type of situation, since every person needs to judge his or her own motives and the use to which the photograph may ultimately be put. News photographers and photojournalists, for example, are often in the situation of

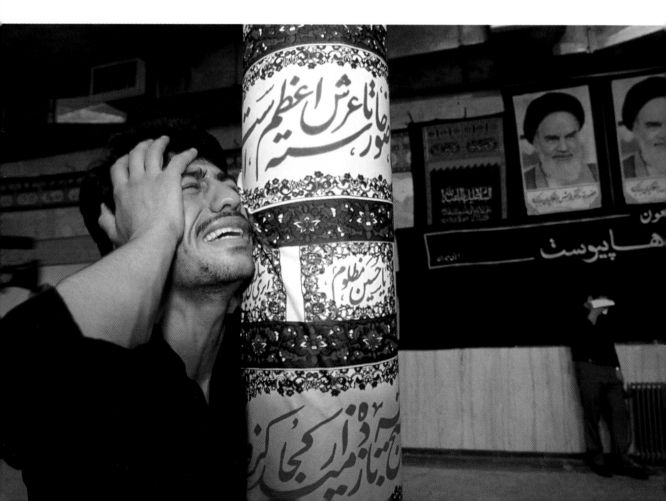

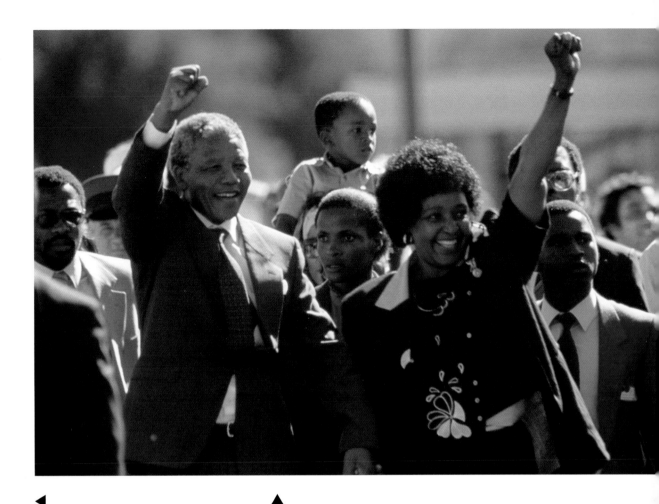

◄

The death of Ayatollah Khomeini, the political and spiritual leader of Iran, was a crucial event in the troubled recent history of that country, and when news of his death became known there followed a period of intense public mourning throughout the country. Although streets full of grieving Iranians were a common sight, the photographer opted for a different picture approach, and this simple image tells the viewer of a grief, which, for this man, was almost palpable.

▲

Pictured soon after his release in 1990 from 26 years in jail as a political prisoner under the old regime in South Africa, the joy on the face of Nelson Mandela, soon to be elected his country's President, is evident – to his people and to the entire world. International press coverage of this turbulent stage of South Africa's recent history was at saturation point, and images such as this appeared on television and in newspapers and magazines in every country around the world.

PHOTOGRAPHER:
Eric Bouvet/Frank Spooner Pictures/Gamma
CAMERA:
35mm
LENS:
250mm
FILM:
ISO 50
EXPOSURE:
½₅₀ second at f11
LIGHTING:
Daylight only

recording all manner of emotional responses to the widest possible range of events, taking pictures that help to inform people throughout the world about what is happening beyond the narrow confines of their own communities or national borders.

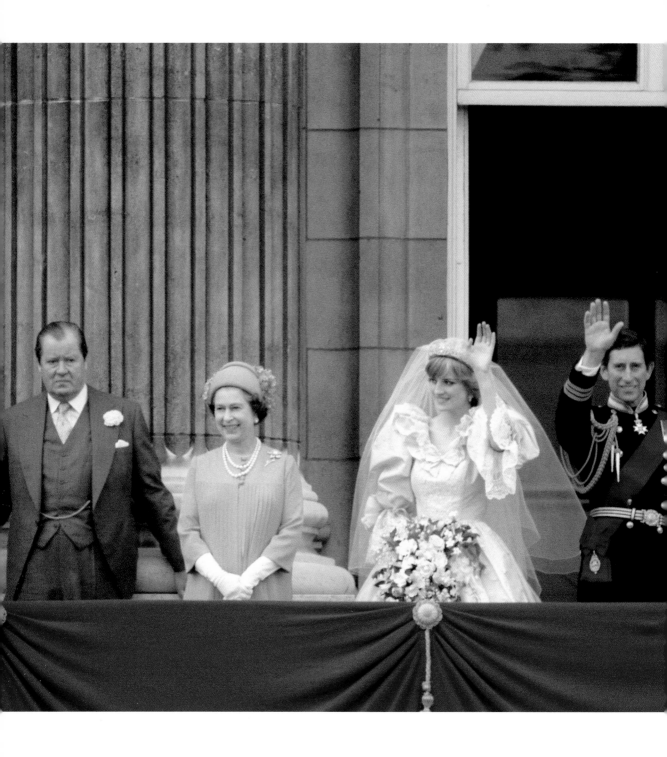

The celebration of a wedding usually brings happiness to both sets of families, but when that wedding is a royal affair, the nation as a whole can become swept up in the emotion of it all. The happiness of the event has been captured from a vantage point beyond the extensive forecourt and gates of Buckingham Palace in London. To achieve this, the photographer used a long lens fitted with a teleconverter in order to produce a good-sized image of Prince Charles and his new wife, Diana, with close members of their families, waving to the crowds below the balcony. Although a teleconverter often results in some loss of lens speed, it does not significantly increase the weight or length of the prime lens it is fitted to.

PHOTOGRAPHER:
Frank Spooner Pictures/Gamma
CAMERA:
35mm
LENS:
600mm (fitted with x1.5 teleconverter)
FILM:
ISO 200
EXPOSURE:
⅟₁₂₅ second at f11
LIGHTING:
Daylight only

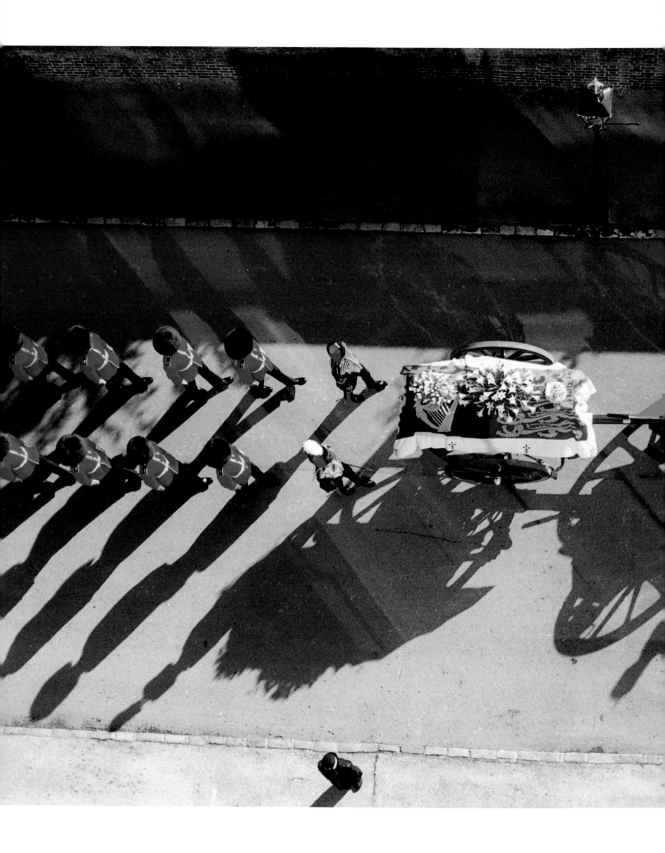

In August 1997, Diana, Princess of Wales, was killed in a tragic car accident in Paris. Here, the poignancy of the occasion has been captured in an image taken from a high vantage point looking directly down on her coffin. The long, sad shadows of early morning express as well as any of the symbols of statehood the sorrow of the occasion.

PHOTOGRAPHER:
Frank Spooner Pictures/Gamma
CAMERA:
35mm
LENS:
90mm
FILM:
ISO 400
EXPOSURE:
1/125 second at f5.6
LIGHTING:
Daylight only

Moments that matter

PHOTOGRAPHER:
Georges Merillon/Frank Spooner Pictures/Gamma
CAMERA:
35mm
LENS:
200mm
FILM:
ISO 200
EXPOSURE:
⅛₂₅ second at f11
LIGHTING:
Daylight only

IT IS THE BUSINESS OF PRESS PHOTOGRAPHERS TO BE IN THE RIGHT PLACE and at the right time to record the political moments that matter. However, achieving this is rarely straightforward. Before press accreditation is granted, photographers often have to present written confirmation from the publication they work for in advance of the political occasion they wish to cover stating that they are bona fide representatives. But since many press photographers are freelance, obtaining this confirmation is not always easy. Then it is often a matter of ensuring that all documentation is forwarded to the appropriate authorities by the due dates and then making numerous follow-up calls, faxes or E-mails before an all-important press pass is issued.

Even when access is granted, photographers still have the problem of finding the best view – they may have to competed for the prime spots, since every photographer present has exactly the same idea in mind. Then you need to read the signs of how the situation is developing and time your shots to capture aspects of the scene that make your pictures more publishable than the others being taken all around you.

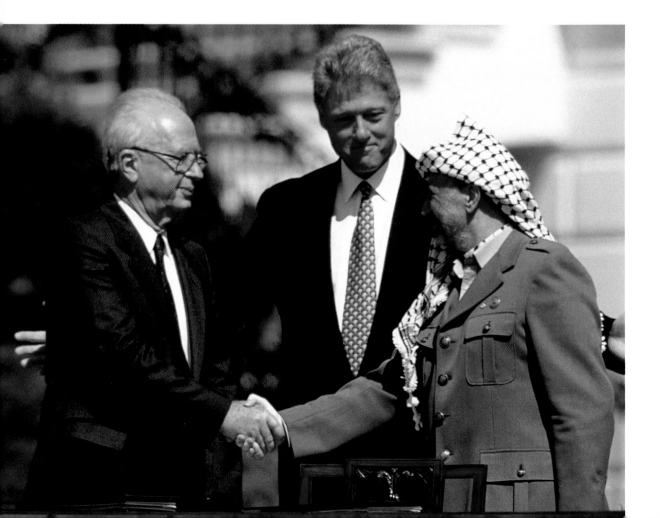

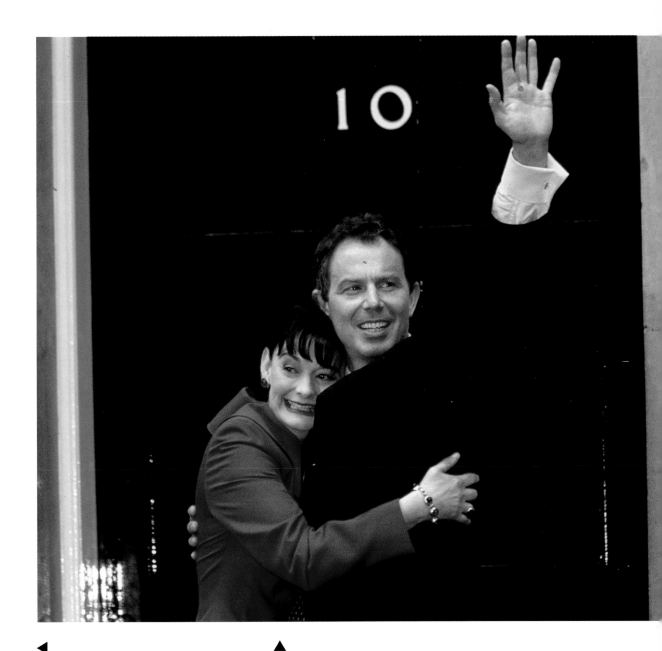

◄

Although not a solution to one of the most intractable political situations in the world, this handshake, between the Israeli Prime Minister and the leader of the PLO, watched by the US President, was at least an acknowledgement by the relevant parties that a new approach was required.

▲

After more than 17 years in opposition, the British Labour Party wins a general election under the leadership of Tony Blair, who automatically becomes the Prime Minister. Seen here, Prime Minister Blair, being hugged by his wife, waves at the assembled well-wishers and photographers from the doorstep of 10 Downing Street, the official residence of all British political heads of state.

PHOTOGRAPHER:
Gavin Smith/Frank Spooner Pictures/Gamma
CAMERA:
35mm
LENS:
210mm
FILM:
ISO 200
EXPOSURE:
$\frac{1}{125}$ second at f5.6
LIGHTING:
Daylight and accessory flash

The emotion generated by the fall of the Berlin Wall, probably to Western eyes the most hated symbol of the former Soviet Union, is difficult to describe, but for future generations photographs such as this will help to convey what it meant for those in Europe living through the last decade of the 20th century.

PHOTOGRAPHER:
Patrick Piel/Frank Spooner Pictures/Gamma
CAMERA:
35mm
LENS:
135mm
FILM:
ISO 200
EXPOSURE:
$\frac{1}{250}$ second at f8
LIGHTING:
Daylight only

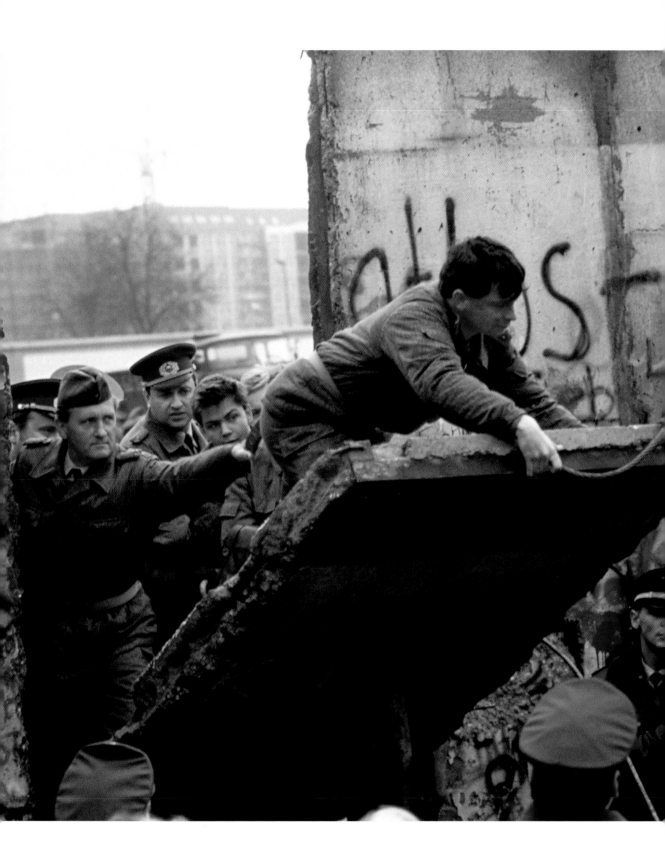

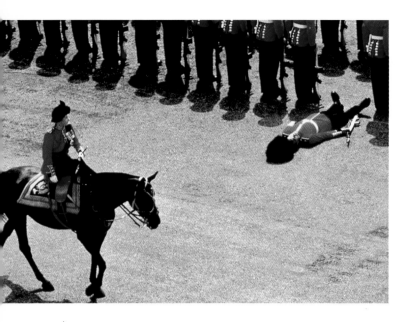

▲

You cannot plan in advance for a picture opportunity such as this – it is all a matter of having quick reflexes and being in the right place at the right time. At the annual ceremony known as 'trooping the colour' in London, which forms part of the Queen of England's birthday celebrations, she glances sideways as her attention is distracted by a soldier, in full ceremonial Guard's uniform, as he faints in the heat of the day, falling in proper military fashion as if still at attention, rifle in hand.

PHOTOGRAPHER:
Frank Spooner Pictures/Gamma
CAMERA:
35mm
LENS:
500mm
FILM:
ISO 100
EXPOSURE:
1/125 second at f16
LIGHTING:
Daylight only

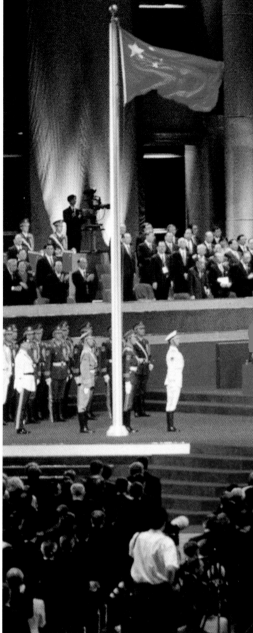

▲

With the assembled dignitaries standing stiffly to attention, and an international audience watching intently, the Union Jack is lowered to symbolize the end of a hundred years of British rule of Hong Kong and that colony's return to China. With so many different light sources present emitting a range of colour temperatures, no film can be used that will show all colours as natural, and the enormous size of the hall meant that any type of flash illumination would be inadequate. But since the content of the photograph is of such crucial importance, the unnatural appearance of some colours hardly matters.

PHOTOGRAPHER:	FILM:
Frank Spooner	ISO 800
Pictures/Gamma	EXPOSURE:
CAMERA:	1/60 second at f5.6
35mm	LIGHTING:
LENS:	Mixed available
35mm	light

Last minute preparations

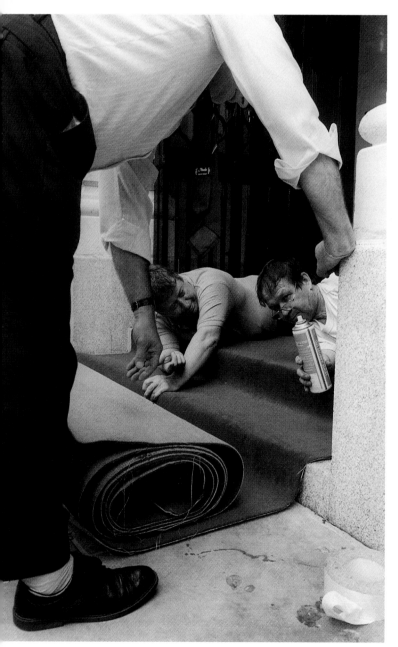

GOOD HUMAN-INTEREST, newsworthy photographs of visits by dignitaries and VIPs can be had before the star attraction has even made an appearance. The photograph below and that on the page opposite show the last-minute, comically frantic preparations outside South Africa House in central London for the imminent arrival of President Nelson

◀

Noticing two carpet layers suddenly emerging from the doorway of South Africa House in London, flat on their bellies to stretch the red carpet flat, the photographer sensed that a photo opportunity could be developing. Quickly worming her way through the crowds and then squatting down low in front of the surrounding legs of the welcoming committee, she had only a seconds to squeeze off a few shots. It was not until inspecting the contact sheets later that she realized she had a real winner with this image showing the strained expression on the face of one of the workmen and the other stretching forward with a can of spray adhesive in his hand.

PHOTOGRAPHER:	FILM:
Linda Sole	**ISO 400**
CAMERA:	EXPOSURE:
35mm	**$\frac{1}{25}$ second at f8**
LENS:	LIGHTING:
50mm	**Daylight only**

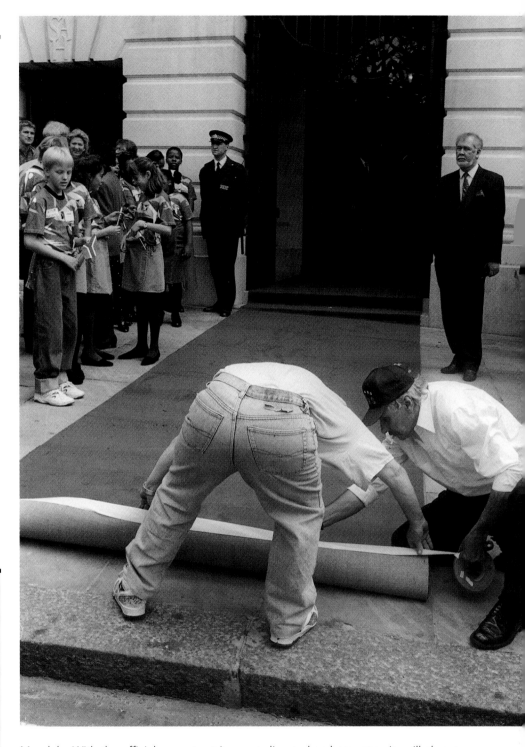

Shooting directly in front of the doorway now, the photographer has framed this shot to show the carpet layers attaching a final strip of adhesive to keep the leading edge of the welcoming red carpet flat to the pavement. But it is the contrast between the stiff formality of the official on the right, and the watchful policeman and excited children opposite, with the workman's rear end stuck defiantly up towards the camera lens in the foreground that gives the image its comic edge.

PHOTOGRAPHER:
Linda Sole
CAMERA:
35mm
LENS:
50mm
FILM:
ISO 400
EXPOSURE:
1/125 second at f11
LIGHTING:
Daylight only

Mandela. With the official car not yet in sight, and the waiting crowd not too large and comprised mainly of children, security was sufficiently informal for these pictures to be taken of the red carpet being hastily glued together and stuck into position by a group of not-too-happy workmen. However, local police and embassy security will always be alert and tense when a visiting head of state is about to arrive, and so it is necessary to work quickly and grab any photo opportunities that arise before your presence is registered and you are ushered further back, from where it may be harder to work.

3

Winning moments

THE SPORTING PHOTOGRAPHS THAT HAVE MOST APPEAL FOR PICTURE EDITORS – and are, therefore, most likely to be used and earn publication fee – are those that capture the emotion, atmosphere and excitement at the very point of victory, when the sportsmen or women realize that the winning moment is theirs.

At many sporting events, professional and amateur, the gallery of accredited press photographers do not have a particular advantage over the well-equipped and experienced amateur photographer who may be sitting in the spectators' areas of the arena. True, press photographers often have their own enclosures, but these are usually only a barrier's width away from where the spectators are seated, and the crush of bodies in the typical press enclosure does not make it particularly easy to work in. At football matches, for example, the press may have access to the sideline areas of the field, but in reality this only gives them a marginal edge. Assuming that you have the right type of equipment – long, fast lenses and some sort of a camera-steadying device such as a monopod or rifle grip – then the telling difference between winning shots and those that will never see the light of day is a matter of timing and your knowledge of the sporting event concerned.

PHOTOGRAPHER:
Popperfoto
CAMERA:
35mm
LENS:
300mm
FILM:
ISO 100
EXPOSURE:
½₅₀ second at f5.6
LIGHTING:
Daylight only

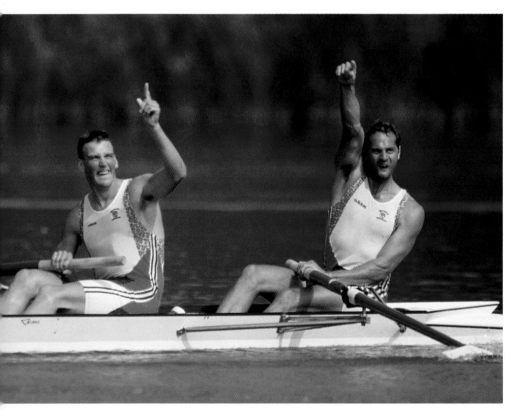

◄

Rowers Matthew Pinsent and Steven Redgrave, in the coxless pairs, have crossed the line to win gold at the Olympic Games. Tracking the rowers with the camera lens, the photographer has held off until the very best moment to record the exhausted athletes punching the air as they realize that the winning moment is theirs to savour.

On the winners' podium, with gold medals around their necks, British coxless pairs rowers Matthew Pinsent and Steven Redgrave stand proudly as their national anthem is played.

PHOTOGRAPHER:
Popperfoto
CAMERA:
35mm
LENS:
270mm
FILM:
ISO 100
EXPOSURE:
⅟₆₀ second at f4
LIGHTING:
Daylight only

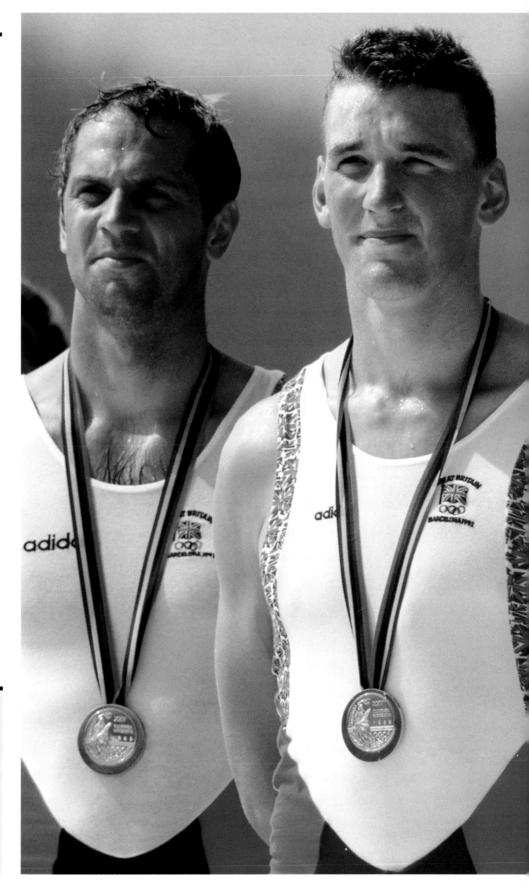

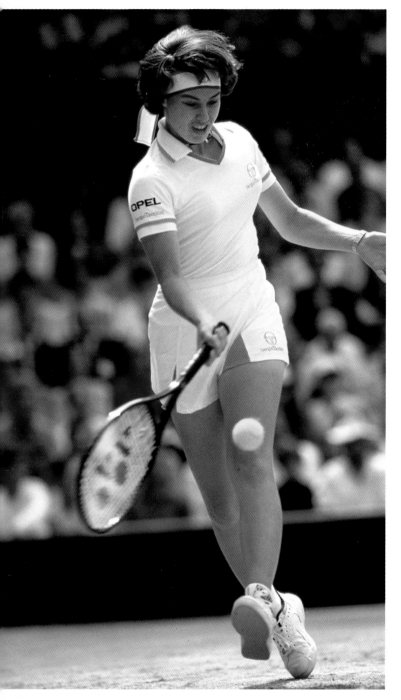

PHOTOGRAPHER:	FILM:
Popperfoto	ISO 50
CAMERA:	EXPOSURE:
35mm	$\frac{1}{125}$ second at f4
LENS:	LIGHTING:
210mm	Daylight only

INSIDER INFORMATION

The better you know the sporting activity you are photographing, the better your chance of capturing a winning, and profitable picture. Finding the right shooting position is vitally important in motor sports, for example, with difficult bends or obvious overtaking stretches of the track being particularly favoured by photographers. In tennis, if you know that a service about to be made is important because its outcome may determine the winner of a crucial game, which, in turn, could decide the winner of a set or match, then you must make sure to record the moment in case it becomes a saleable picture. In a football match, if you know who the key players are and who is likely to be receiving the ball as a particular play develops, you may be able to predict where on the field you should concentrate your attention and have the camera controls set in advance.

◄

Switzerland's Martina Hingis runs across the court to deliver a forehand return. The photographer has captured all of the excitement of the Wimbledon Lawn Tennis Championships, with the tennis star concentrating intently on the ball, as she heads towards victory in the ladies' singles.

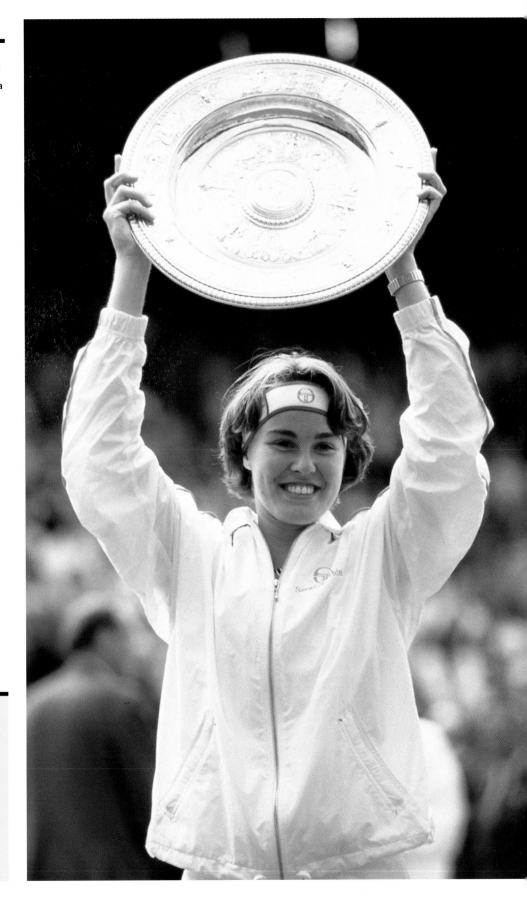

After the tension and high drama of the match, Martina Hingis holds aloft the famous Wimbledon ladies' singles trophy. At just 16 years of age, she is the youngest ever winner, and the relief and pure joy is evident in her face.

PHOTOGRAPHER:
Popperfoto
CAMERA:
35mm
LENS:
250mm
FILM:
ISO 50
EXPOSURE:
1/125 second at f4
LIGHTING:
Daylight only

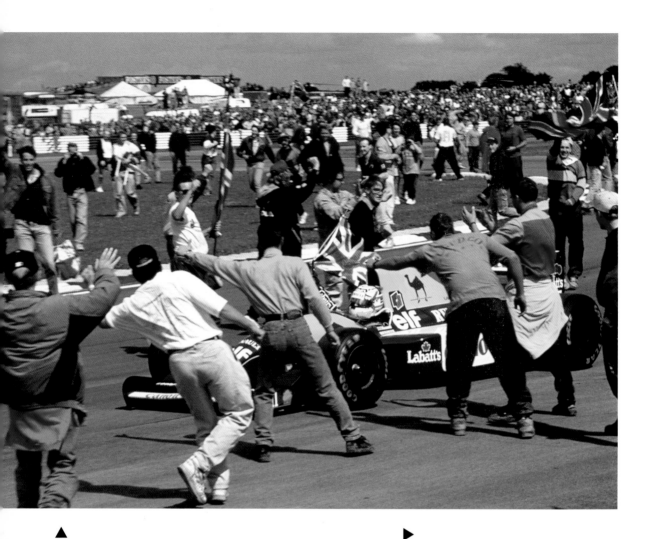

▲

The fans go wild and swarm over the track as Britain's Nigel Mansell, in a Williams Formula One car, cruises to a stop after winning the British Grand Prix at Silverstone. This type of shot is equally open to amateur and press photographers alike, since special access is not required and neither is specialist equipment.

PHOTOGRAPHER:
Popperfoto
CAMERA:
35mm
LENS:
135mm
FILM:
ISO 200
EXPOSURE:
1/500 second at f5.6
LIGHTING:
Daylight only

▶

A perfect shot when used in conjunction with the previous picture – here Nigel Mansell receives the adoration of the assembled fans as he stands, arms raised and cap in hand, grinning broadly on the winner's podium after successfully completing the British leg of the Formula One racing calendar in front of an ecstatic home crowd.

PHOTOGRAPHER:
Popperfoto
CAMERA:
35mm
LENS:
100mm (with x2 teleconverter)

FILM:
ISO 200
EXPOSURE:
1/125 second at f8
LIGHTING:
Daylight only

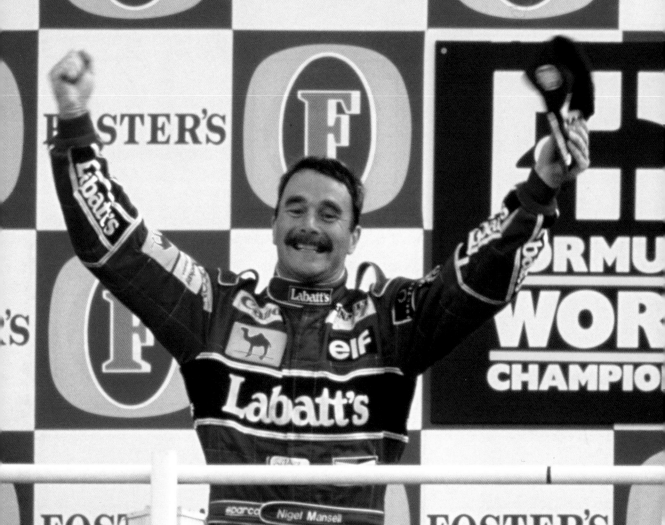

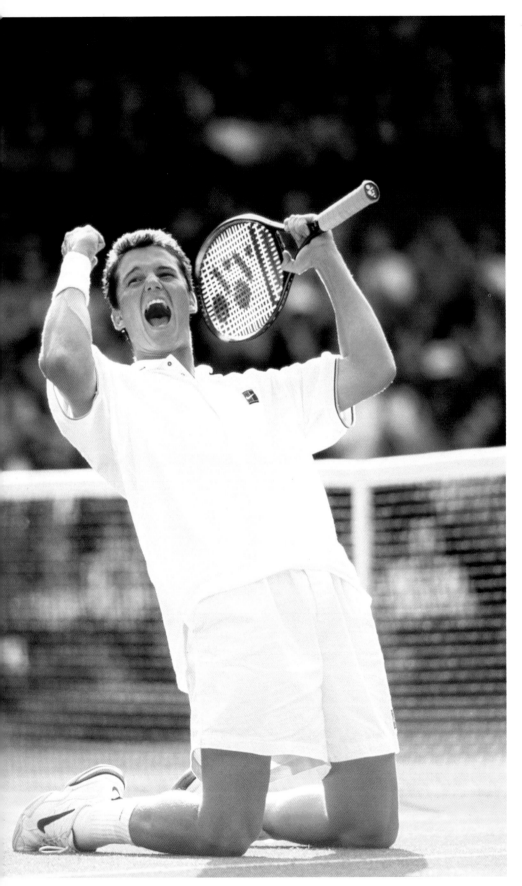

No picture could better express the elation Holland's Richard Krajicek felt at the winning moment at the Wimbledon Lawn Tennis Championships. Timing is important beyond measure for the success of this type of image, and the photographer has carried it off to perfection.

PHOTOGRAPHER:
Popperfoto
CAMERA:
35mm
LENS:
200mm
FILM:
ISO 200
EXPOSURE:
1/500 second at f4
LIGHTING:
Daylight only

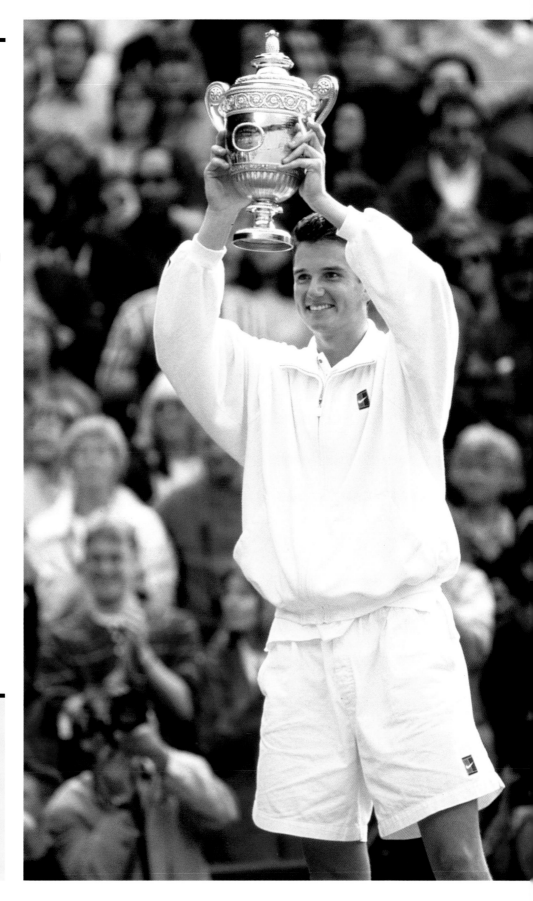

Calmer, but still bubbling with excitement, Richard Krajicek lifts the men's singles cup up to the ranks of spectators at Wimbledon's centre court, the battleground of some of the best lawn tennis played anywhere in the world.

PHOTOGRAPHER:
Popperfoto
CAMERA:
35mm
LENS:
270mm
FILM:
ISO 200
EXPOSURE:
½₀₀ second at f8
LIGHTING:
Daylight only

Brazil's captain clutches the World Cup trophy at the end of the final game, in which Italy was beaten 3–2 on penalties. The whole team was gathered together for this photo-call, but the photographer has concentrated on the trophy itself and zoomed in for a close-up. Even though only a few team members can be seen, their happiness and the feeling of camaraderie is evident.

PHOTOGRAPHER:
Popperfoto
CAMERA:
35mm
LENS:
80–210mm zoom (set at 210mm)
FILM:
ISO 200
EXPOSURE:
$\frac{1}{250}$ second at f11
LIGHTING:
Daylight only

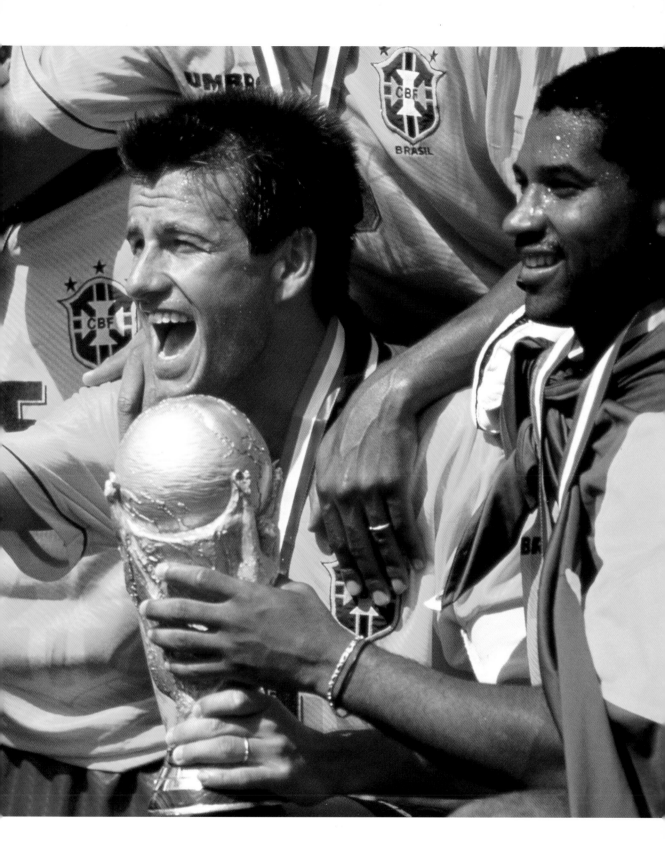

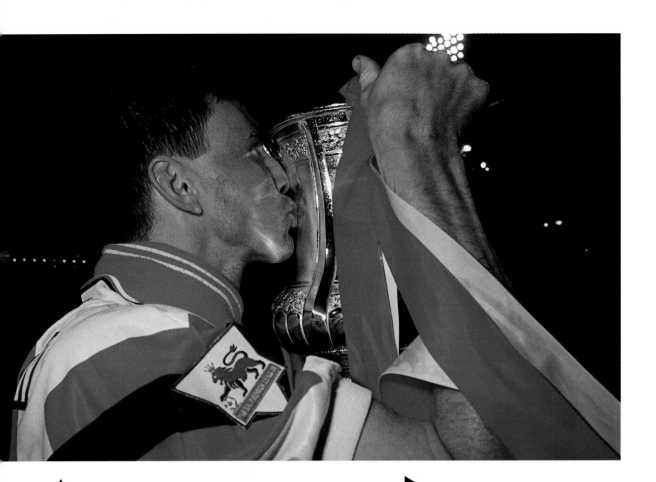

▲

In terms of British Cup football, there can be no more special moment than this – lifting the winners' cup and kissing the historic trophy. Here, the honour fell to Arsenal's winning goal-scorer, Andy Linighan. Night had already fallen by the time the match was decided, leaving the photographers covering the event dependent on accessory flash as the principal form of illumination. Although the stadium is ringed with high banks of spotlights, this lighting is insufficient for photography and of the wrong colour temperature.

PHOTOGRAPHER:
Popperfoto
CAMERA:
35mm
LENS:
28mm
FILM:
ISO 400
EXPOSURE:
⅙₀ second at f5.6
LIGHTING:
Accessory flash

▶

Even for national sportsmen, an opportunity to meet the Queen of England is a very special occasion – if not a little nerve-wracking, as you can see from the strained expressions on the faces of the members of the team as their captain, Will Carling, introduces each to the VIP. This part of the opening ceremony of the international rugby union competition between England and Wales was, of course, known well in advance of the match and so photographers knew to be prepared and in position.

PHOTOGRAPHER: FILM:
Popperfoto **ISO 200**
CAMERA: EXPOSURE:
35mm **⅙₀ second at f16**
LENS: LIGHTING:
600mm **Daylight only**

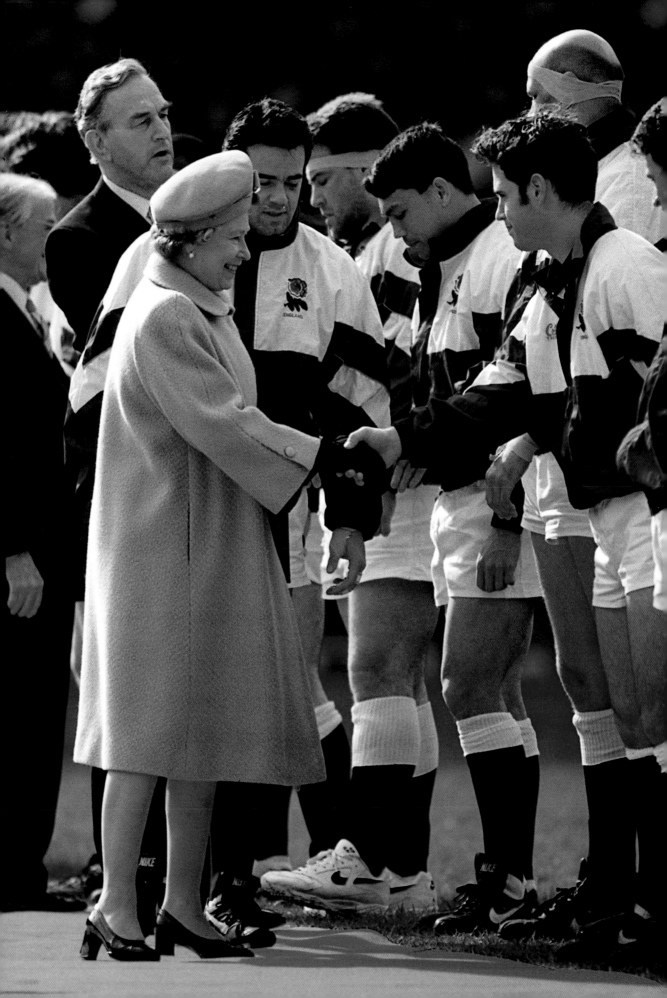

▶

What could be a better moment for American athlete Michael Johnson? He has just won gold at the Atlanta Olympics in the 200 metres final in front of a home crowd. Not only that, at the very moment the picture was taken, he was told that he had also set a new world record time for the event.

PHOTOGRAPHER:
Popperfoto
CAMERA:
35mm
LENS:
500mm
FILM:
ISO 100
EXPOSURE:
⅟₁₂₅ second at f8
LIGHTING:
Daylight only

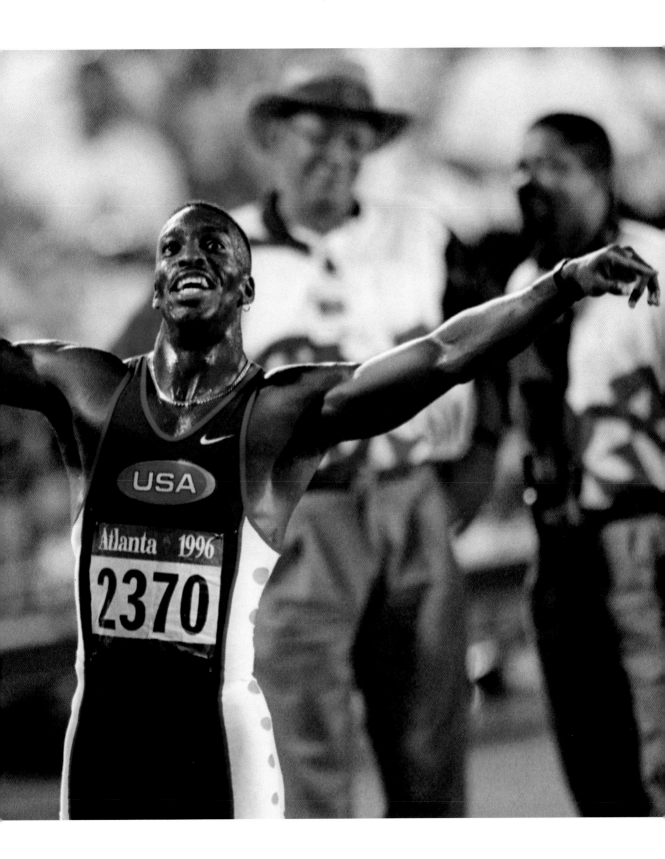

Youth events

ALTHOUGH THEY MAY BE YOUNG, playing in a full match is a special occasion for the children and their commitment to the sport and the excitement they generate can be just as great as that displayed by their professional counterparts. The huge advantage you have when photographing a youth sporting match is that you will generally not be restricted to a single camera position. The extra freedom of movement you have allows you to follow the direction of play on the sidelines, positioning yourself perfectly for whatever is happening on the field at any particular time. Since you can keep up with the ebb and flow of the action, thus minimizing the distance between camera and subjects, you can get away with using shorter, less expensive and lighter-weight lenses than you would need if confined somewhere way back in the spectators' stands. Also, the variety of shooting angles at your disposal is likely to result in a generally more interesting set of slides or prints.

◀

Concentrating on the ball while fending off an opposing defender, the shot of this young footballer would make a perfect print in an exhibition of work for sale. The focus is pin-sharp, which is always difficult with fast-moving subjects, and the depth of field is narrow enough to have thrown the rest of the field into soft focus.

PHOTOGRAPHER:	FILM:
Popperfoto	**ISO 200**
CAMERA:	EXPOSURE:
35mm	**½₅₀ second at f4**
LENS:	LIGHTING:
300mm	**Daylight only**

COMMERCIAL POSSIBILITIES

There is always the possibility of turning a day's shooting at a youth sporting event into a profitable sideline. As a first step, contact the organizers – this could be the school or schools involved from which the competitors come, for example, a local youth club or some type of organized youth coaching scheme – to obtain permission to photograph the event in some sort of official capacity. The idea would be to run up an exhibition of your best work – 20 x 25cm (8 x 10in) is a good size – to be displayed by the organizers at the schools involved or the youth club. You could donate the exhibition set of prints to the organizers as an incentive for their cooperation, while the children or their parents could order reprints for an amount that covers costs and shows you a profit. Don't ignore the possibility of selling the occasional picture to a local newspaper either. These publications usually run with a minimum of staff and so rely on material sent in by the public. Although reproduction fees will not be great, having your work published could open up career possibilities and future commissions.

▶

Moments like this are priceless. Caught out in some misdemeanour during a training session for both boys and girls, one player can be seen remonstrating good-naturedly with the coach while another, clutching the coach's jeans for balance, sits on a ball waiting for the action to resume.

PHOTOGRAPHER:	FILM:
Popperfoto	**ISO 100**
CAMERA:	EXPOSURE:
35mm	**⅟₂₅ second at f11**
LENS:	LIGHTING:
135mm	**Daylight only**

The photographer has chosen an ideal shooting position – head-on to the action – to capture the effort, concentration and determination on the faces of these youth players. All subject movement has been frozen, even though the shutter speed used was not particularly brief. This is because the direction of the action was directly towards the camera – had movement been at, say, 90° to the camera, a much faster shutter speed would have been required to achieve the same effect.

PHOTOGRAPHER:
Popperfoto
CAMERA:
35mm
LENS:
300mm
FILM:
ISO 200
EXPOSURE:
½₅₀ second at f5.6
LIGHTING:
Daylight only

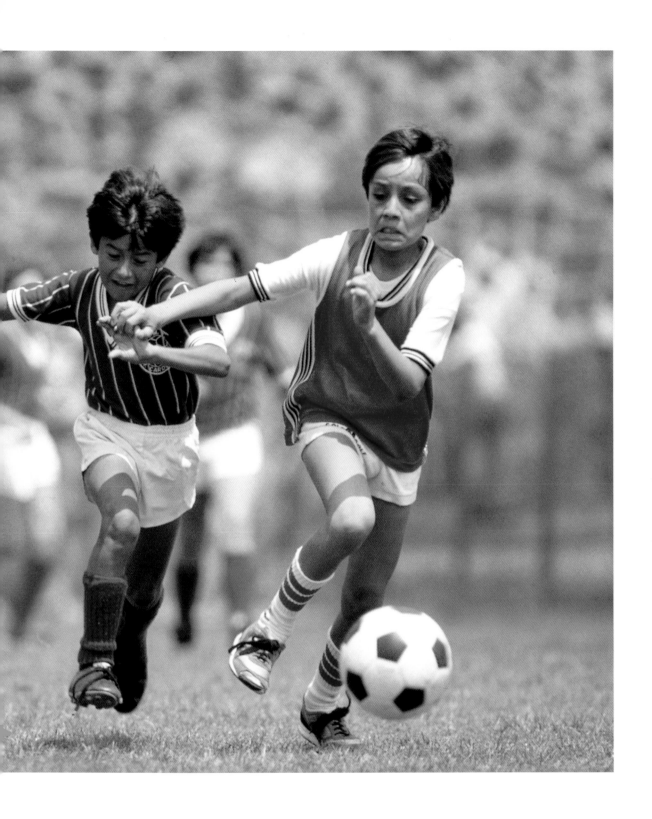

Picture story

PHOTOGRAPHER:
**Finale Coupe
du Monde 98/
Frank Spooner
Pictures/Gamma**
CAMERA:
35mm
LENS:
600mm
FILM:
ISO 400
EXPOSURE:
½₅₀ second at f5.6
LIGHTING:
Daylight only

FOR FRANCE, ONE OF THE COUNTRIES that was most responsible for the establishment of the World Cup football competition, this was to be a year to remember and cherish. Winning through the early elimination rounds of the competition, the whispers coming out from the French camp was that support from the overwhelmingly French crowds at matches was lacklustre – the absence of vociferous support from the terraces was affecting morale and the performance of the national team. By the time the finalists had been decided, however, the situation had been completely turned around – the team's continuing success meant that the scene was now set for a France vs Brazil finale, and the public was right behind them. And the international press was there in their thousands, too, to record every moment of what was assumed to be another South American victory – for France, their first time ever in the finals, was pitted against the most successful and charismatic team in the competition's history.

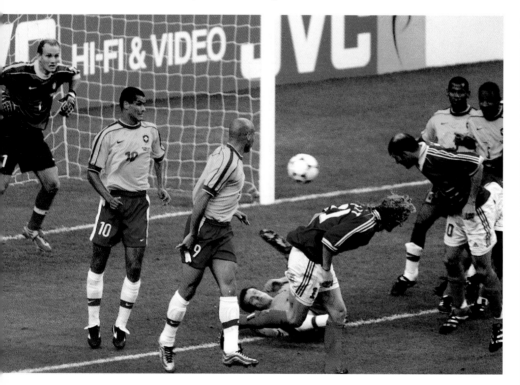

◄

The camera's ability to freeze an instant in time has been used to good advantage in this shot, showing a French-headed ball whistling towards the net as the Brazilian goalkeeper, feet off the ground, appears unaware of the impending disaster for his team. The tension is clear in the body language of the Brazilian defenders, as one simply turns his heads to follow the progress of the ball into the net.

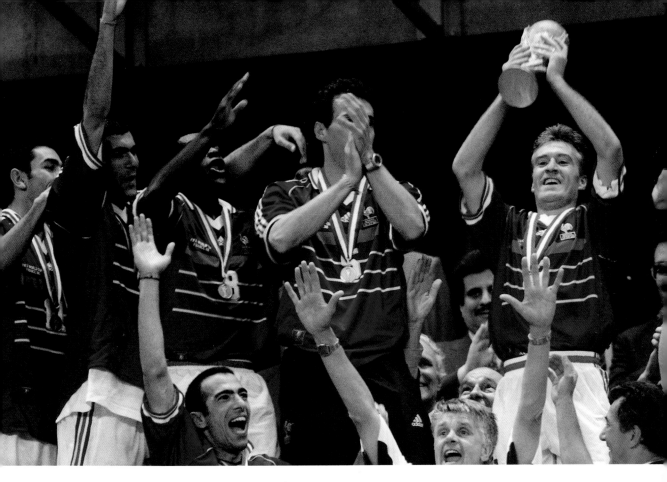

CHOOSING LENSES

Whether you are in the press enclosures or in the spectators' stands, a long lens is essential if you want to record the action in any detail. A football pitch is so wide and long, however, that a fixed focal length (or prime) lens may be fine when the players are at certain distances from your position, but it may be either too long or too short at other times. To cope with this, professional photographers either have an array of cameras at their disposal, each mounted with a different prime lens, or they use zoom lenses. Probably the most flexible zoom in these circumstances is something in the region of 170–500mm. Bear in mind that a long, fixed focal length telephoto (except a mirror lens) or an extreme telephoto zoom, is heavy and will require some form of sturdy support, such as a tripod, monopod or rifle grip, to avoid camera shake and unusable images.

▲

With the World Cup trophy in their hands at last, the enormity of their victory seems to have just sunk in, and it is not difficult to read the emotion in the faces of the team, with their hands aloft and their winners' medals around their necks.

On the day of the final, the reserved press enclosures were bulging with photographers, and there was not a spare seat to be found anywhere in the spectators' stands either. If a lack of involvement from the French fans had been a problem in the early rounds of the competition, at this point the atmosphere was electric with noise – singing and chanting that rose to a deafening crescendo when the final whistle blew with the score standing at France 3 and Brazil an unbelievable 0.

PHOTOGRAPHER:
Finale Coupe du Monde 98/ Frank Spooner Pictures/Gamma
CAMERA:
35mm
LENS:
250mm
FILM:
ISO 200
EXPOSURE:
1/125 second at f8
LIGHTING:
Daylight only

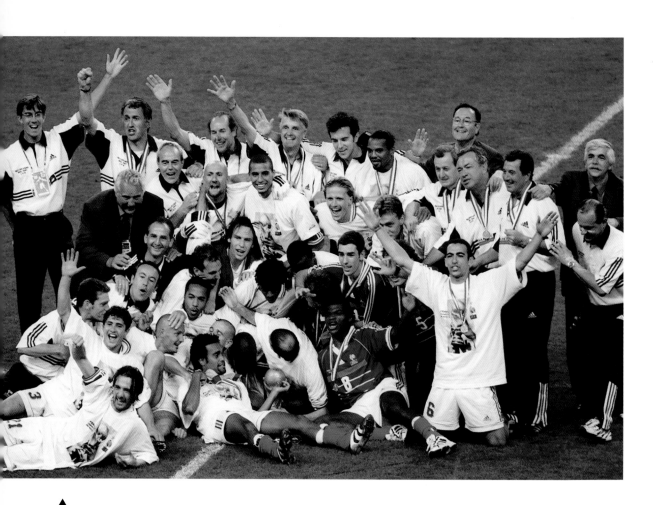

▲

With excitement still bubbling up to the surface, the French World Cup squad members are gathered together for a victory photograph, including the players and the other key training and support personnel. The slightly elevated shooting position of the photographer helps to overcome one of the potential problems encountered whenever you are shooting large group portraits – that of overlapping and obscured faces. With the dynamics of the group changing second by second, set the camera to 'continuous', shoot a roll of film, and select the best shots afterwards in the calmer atmosphere of the studio. Many specialist sports photographers send their unprocessed film back to their picture editors at the newspaper or magazine they work for and leave it to them to make the decisions about which shots to use.

PHOTOGRAPHER:
Photo News/Frank Spooner Pictures/Gamma
CAMERA:
35mm
LENS:
80mm
FILM:
ISO 200
EXPOSURE:
1⁄250 second at f11
LIGHTING:
Daylight only

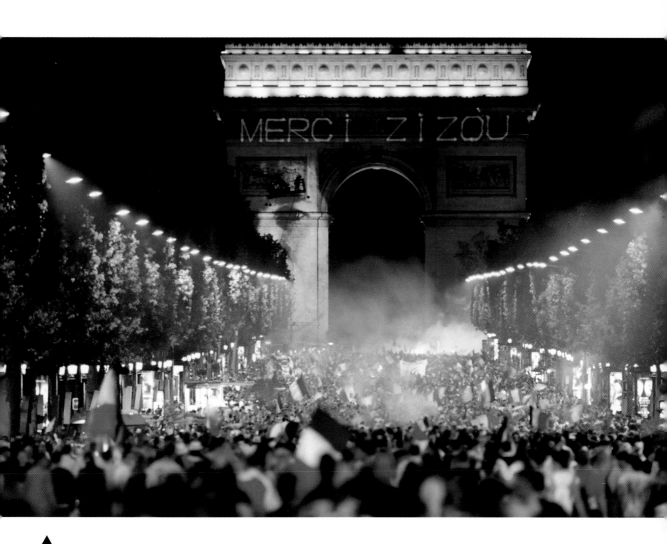

▲

With the tricolour in evidence everywhere, this is the evening of France's historic, first-ever victory in the World Cup, and Paris has gone wild. The crowds in and around the Champs Élysées were estimated to be more than a million strong – in fact, there had not been a celebration to match these scenes since the liberation of Paris at the end of the World War II. The street lighting above the trees is reminiscent of stadium lighting, creating an envelope of light that seems physically to constrain the excited crowds. With the lens wide open at maximum aperture, the resulting shallow depth of field is evident in the out-of-focus figures in the immediate foreground of the scene. When print film is used, colour casts caused by non-photographic light sources can be largely corrected at the printing stage. With slide film, however, you need to use a film balanced for the principal type of lighting in the scene and simply live with any resulting colour casts produced by less-important light sources.

PHOTOGRAPHER:
Deville Duebs/
Frank Spooner
Pictures/Gamma
CAMERA:
35mm
LENS:
500mm
FILM:
ISO 800
EXPOSURE:
1/25 second at f4
LIGHTING:
Available street
lighting

The fans

ALTHOUGH THE OBVIOUS CENTRE OF ATTENTION at a sporting event is the competitors themselves, you will sometimes find huge potential pictorial interest simply by turning the camera around and focusing on the fans instead. Young followers, in particular, of sporting teams have a great sense of the 'special occasion' and can go to great lengths to dress in the full regalia of their teams, and shots such as those shown here are often published in the sporting pages of newspapers and magazines as back-up images for the more traditional action pictures of the event itself.

If you are in the midst of the fans, then a wide-angle lens can help to produce a real sense of what it feels like to really be there, with the crowds pressing in on you

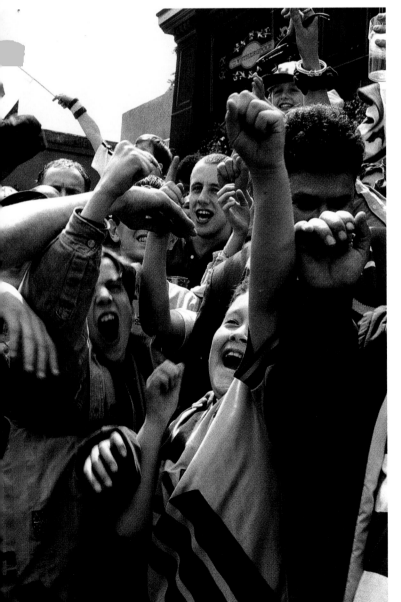

◄

The fans go wild with excitement in the streets of London as the bus carrying their victorious football team pulls into view – Arsenal was bringing home the FA cup. From her position on the pavement, the photographer could not get a worthwhile shot of the open-topped team bus, so she turned around and snapped this action-packed view. You cannot preplan this type of image, since everything depends on fleeting facial expressions, fists punching the air, hats being thrown and flags being waved. All you can do is preset the camera controls to give you the best compromise between an extensive depth of field and a sufficiently fast shutter speed to freeze most subject movement.

PHOTOGRAPHER:	FILM:
Linda Sole	**ISO 400**
CAMERA:	EXPOSURE:
35mm	**1/250 second at f8**
LENS:	LIGHTING:
28mm	**Daylight only**

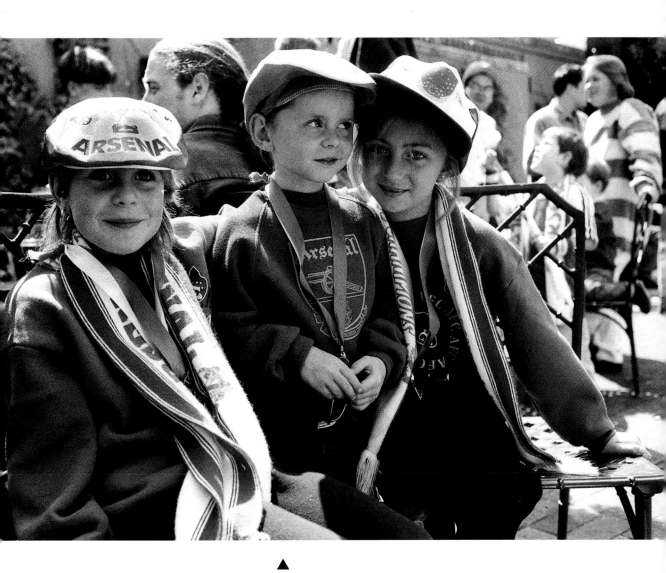

▲

and all the accompanying noise and loads of atmosphere. If, however, your attention has been taken by a small grouping of individual fans, then a moderate telephoto or zoom lens may be more appropriate, since its more restricted angle of view is useful for cropping out extraneous elements in the scene, leaving only the really important material for the camera to record. Select an aperture that produces the maximum possible depth of field (without risking too slow a shutter speed that could give rise to camera shake) in order to mask any minor focusing errors.

In a quiet corner not far from the deliriously happy hoards of fans welcoming the victorious Arsenal football team home to north London, the photographer happened on these three young fans dressed from top to toe in their team's regalia. Too small to be in the middle of the action at the end of the street, they were thrilled to have attracted the attention of the photographer and were pleased to pose for the shot. This is exactly the type of photograph that, say, a local newspaper would be pleased to print as part of a well-rounded pictorial coverage of this very special occasion.

PHOTOGRAPHER:
Linda Sole
CAMERA:
35mm
LENS:
90mm
FILM:
ISO 400
EXPOSURE:
1/125 second at f5.6
LIGHTING:
Daylight only

4

PORTRAITS

Shooting on location

PHOTOGRAPHER:
Kate Dawson
CAMERA:
35mm
LENS:
28mm
FILM:
ISO 200
EXPOSURE:
⅟₂₅ second at f5.6
LIGHTING:
Daylight only

THERE WILL BE MANY INSTANCES WHEN THE STUDIO SETTING IS INAPPROPRIATE for the needs of particular clients. It could be that they simply do not like the studio environment and would rather be photographed in their own home, or at some other venue, where they feel relaxed and confident – don't forget that many people are stressed by being placed in front of a camera and lights. It could also be that the special occasion you have been commissioned to photograph involves a whole group of people and that you need to attend the event in order to record the action as it unfolds. It could also be that the location itself is of particular significance and that the portrait would be meaningless in any other setting.

If at all possible, visit the location before the day of the photo session. Also, try to get there at about the same time of day as the real session so that you can judge the amount and quality of any natural daylight you will have to work with. While there, also note the position of power outlets in case you need to supplement the daylight with studio lights.

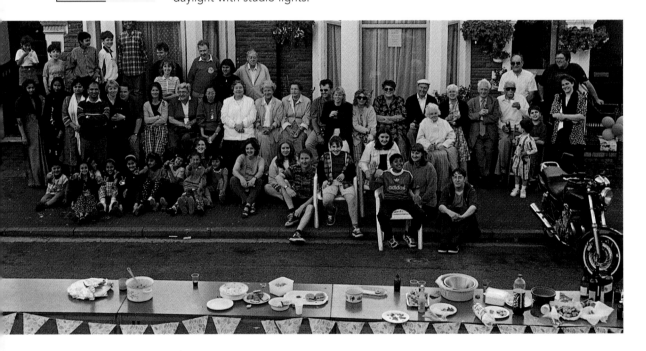

▲

After photographing each of the families living in this small suburban road in their own homes (see right), all the residents came together and held an old-fashioned street party. The road was quite narrow and the available daylight tended to bounce back and forth from the surrounding house frontages. This meant that, down at street level where everybody had gathered, lighting levels were low but very even.

▶

This family portrait is full of detail that invites the eye to explore the frame. Had it not been taken in black and white, the many colours in the women's saris, the patterned rug and carpet and the Victorian-style volume of ornaments would have been overwhelming. As a monochrome image, however, all you see is a mellow and pleasing blend of tones and half-tones. Shooting against the light like this, it was necessary to boost lighting levels by using a portable studio flash. This was angled upwards, towards the ceiling, so that a gentle light was reflected back on to the subjects. Direct flash is most often unflattering and would have glared back towards the camera from the reflective surface of the silk saris.

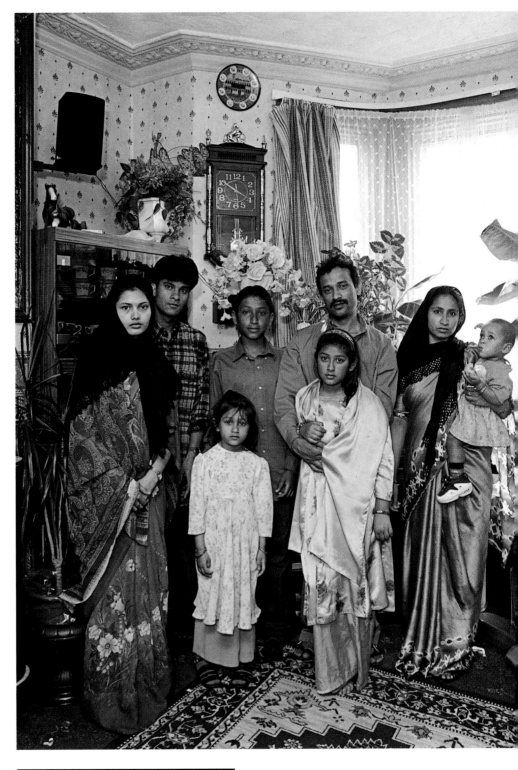

PHOTOGRAPHER:	EXPOSURE:
Kate Dawson	⅟₆₀ second at f8
CAMERA:	LIGHTING:
35mm	Daylight and studio
LENS:	flash
70mm	
FILM:	
ISO 200	

◀ ▶

Rather than being a special occasion for the young subjects featuring in these photographs, it was more of an event for the photographer. The opportunity to photograph in the gypsy camp where these children live came about only after a long period of negotiation. The photographer undertook to make a complete record of the day-to-day lives of the families living there, which, given the decline in the number of gypsies living a traditional lifestyle, represents a vital historical archive.

PHOTOGRAPHER:
Matt Griggs
CAMERA:
35mm
LENS:
80–210mm zoom (set at 120mm)
FILM:
ISO 125
EXPOSURE:
⅟₆₀ second at f8
LIGHTING:
Daylight and flash

PHOTOGRAPHER:
Matt Griggs
CAMERA:
35mm
LENS:
80–210mm zoom (set at 80mm)
FILM:
ISO 125
EXPOSURE:
⅟₃₀ second at f8
LIGHTING:
Daylight only

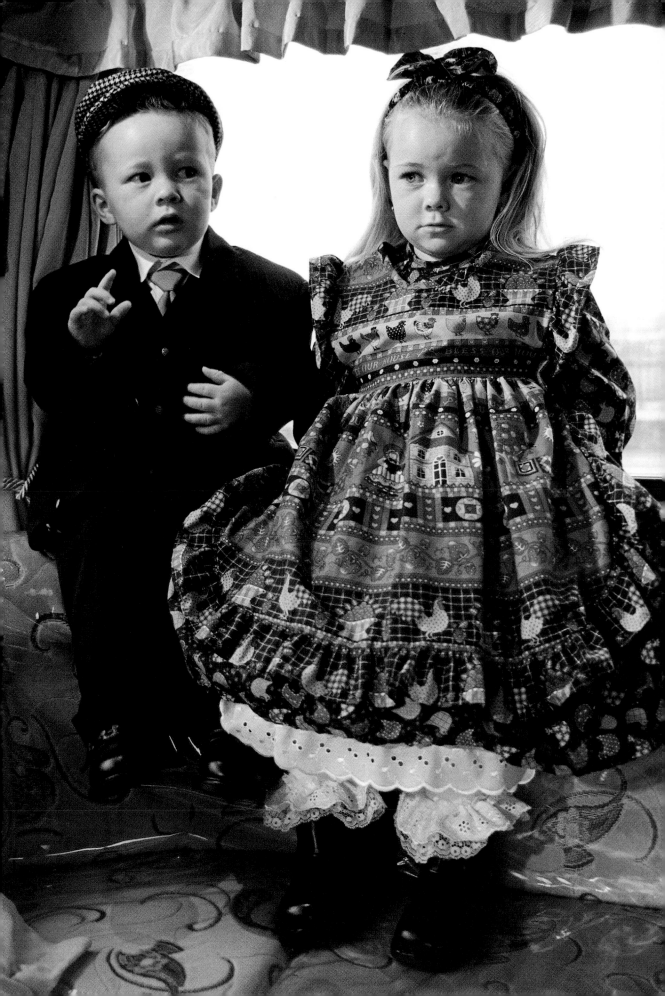

IMPORTANCE OF EYELINE

When photographing children and babies it is unwise to shoot from the normal standing height of an adult. Instead, squat down so that the camera and subjects share approximately the same eyeline. Shooting from above, the camera sees largely the top of the head and forehead. A high shooting angle also has the effect of diminishing their apparent stature. Portraits taken in which the face, and especially the eyes, can be clearly seen communicate far more effectively with the picture's audience. To take this shot, the baby's first professional portrait, the photographer had to lie down flat on his stomach so that, in fact, he was shooting slightly upwards at the subject.

PHOTOGRAPHER:
Robert Hallmann
CAMERA:
6 x 6cm
LENS:
180mm
FILM:
ISO 100
EXPOSURE:
½₅₀ second at f4
LIGHTING:
Daylight only

▶

The 300th anniversary of the establishment of this tobacconist's shop was the special occasion being celebrated in this location portrait. There was some low-level available daylight entering through a plate-glass window (out of shot), but this was not nearly enough to show the wealth of fascinating historic and contemporary details crammed into every corner and on every shelf lining the walls. The floor area inside was not large to work in and so the photographer set up a studio flash unit outside, its head directed at the window so that the daylight and flash light coincided and no conflicting shadows were produced. At the appropriate moment, the photographer directed the proprietor to light his pipe and glance upward at the camera. The subject's glasses had to be far down on his nose to prevent the lenses returning the flash light.

PHOTOGRAPHER:	EXPOSURE:
John Freeman	⅟₃₀ second at f16
CAMERA:	LIGHTING:
5 x 4in	Studio flash x 1
LENS:	(fitted with a
90mm	softbox) and weak
FILM:	daylight
ISO 100	

▶

The setting for this wedding anniversary portrait was the couple's conservatory. Too much toplighting was the immediate problem in this all-glass room, but by pulling the canopy-style blinds across the roof panels the photographer managed to filter and soften the daylight considerably. This, however, left the problem of matching the light indoors with that in the garden beyond, since now there was nearly a two-stop difference between the subjects' shadowy faces and an outside exposure reading. To overcome this, the photographer used a single portable studio flash and softbox set to a power output that provided just the right amount of fill-in flash. The far doors had to be opened, though, to prevent the glass panes reflecting the flash light. By directing the flash predominantly at the subjects' faces, it was possible to retain the natural dappled lighting effect on the conservatory floor.

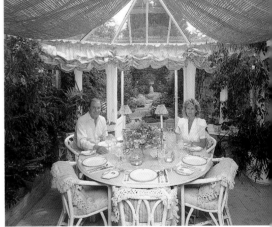

PHOTOGRAPHER:	EXPOSURE:
John Freeman	⅟₁₅ second at f22
CAMERA:	LIGHTING:
5 x 4in	Daylight and fill-in
LENS:	flash
90mm	
FILM:	
ISO 100	

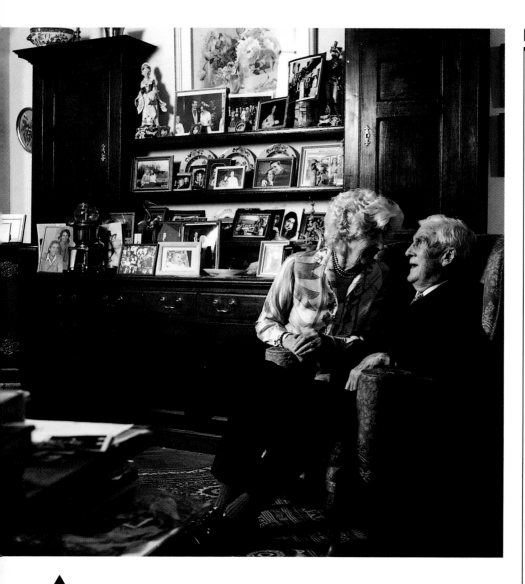

To celebrate the 60th wedding anniversary of their parents, the children of this couple commissioned the photographer to take a series of portraits in the family home, one of which you can see above, as well as colour shots of the larger 'gathering of the clan' later that same day (opposite). The affection between the man and woman is obvious in the intimate setting of their own sitting room and in their relaxed body language, while their many years of happy married life can be seen in the volume of framed photographs on the dresser behind them. The only light used for the shot was daylight entering the room from windows opposite the couple. A mid-tone light reading was taken and the shadows were basically allowed to look after themselves.

PHOTOGRAPHER:
Richard Galloway
CAMERA:
6 x 6cm
LENS:
80mm
FILM:
ISO 400
EXPOSURE:
⅙₀ second at f5.6
LIGHTING:
Daylight only

Organizing a large group portrait such as this is difficult simply because of the number of people to be arranged so that all important facial features can be seen. And when you are working on a flat piece of land, such as this pebbly beach, you cannot take advantage of any features in the landscape to give some subjects a little extra height. In the main group shot (top), all those shown are related to the anniversary couple in the middle. After you have taken the main group portrait, it is best to break the people up into smaller, more manageable numbers and take more intimate group portraits – perhaps of the anniversary couple with their children only, then with their grandchildren as well, and so on.

PHOTOGRAPHER:
Richard Galloway
CAMERA:
35mm
LENS:
35mm
FILM:
ISO 100
EXPOSURE:
1/25 second at f11
LIGHTING:
Daylight only

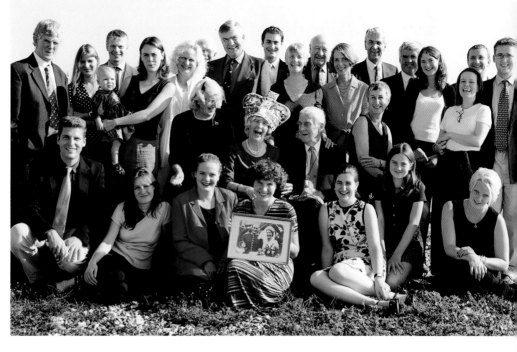

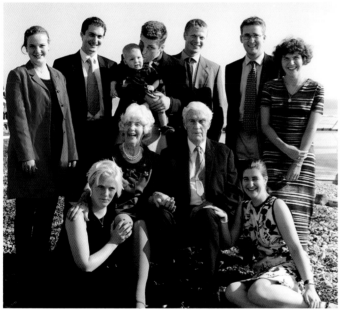

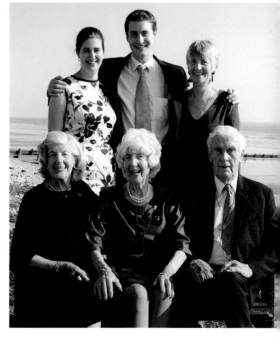

PHOTOGRAPHER: FILM:
Richard Galloway **ISO 100**
CAMERA: EXPOSURE:
35mm **1/25 second at f8**
LENS: LIGHTING:
80mm **Daylight only**

PHOTOGRAPHER: FILM:
Richard Galloway **ISO 100**
CAMERA: EXPOSURE:
35mm **1/25 second at f8**
LENS: LIGHTING:
80mm **Daylight only**

Keeping in touch

PHOTOGRAPHER:
John Freeman
CAMERA:
6 x 7cm
LENS:
140mm
FILM:
ISO 100
EXPOSURE:
⅟₃₀ second at f16
LIGHTING:
Studio flash x 1 (fitted with a softbox), plus reflector

A SPECIAL OCCASION DOES NOT HAVE TO BE A MAJOR LIFE EVENT. What triggers a photographic commission for a portrait is often a very personal observance of something that might, in all likelihood, have no particular significance for anybody else. The more you can learn from your clients about what has prompted them to be in your studio, however, the more you can tweak the direction the session takes to produce a set of pictures that best fulfils their intentions.

The story lying behind the pictures below and opposite could not be simpler. The young woman shown had lived in London ever since her immediate family emigrated from west Africa, nearly 15 years earlier. Left behind was her extended family of aunts, uncles, cousins and so on, none of whom had seen her since she was a child. On her 25th birthday, she decided to have a set of professional portrait pictures taken so that she could send prints off to her family, who still thought of her the awkward 10 year old they had last seen.

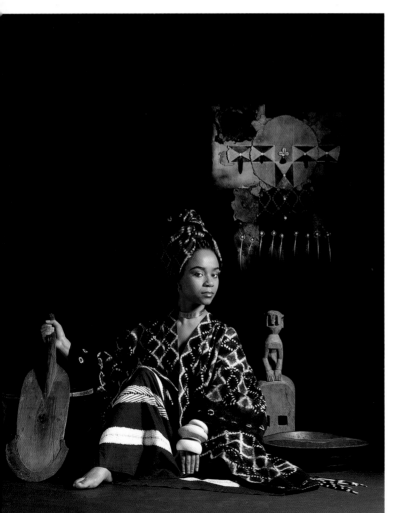

◄

Knowing that the client wanted a striking portrait to send to family members she had not seen for many years, the photographer opted for a simple, stark set with very little to distract attention from the figure. He used dark grey background paper as a backdrop, and extended it forward to act as the floor as well. Lighting was a single studio flash and softbox on one side of the camera and a large reflector opposite, used to direct light into the shadows on that side. If the background paper receives too much illumination it will lighten in tone, so to keep it dark you need either to distance the subject from the background or direct the flash head carefully so that any illumination spilling past the subject falls harmlessly out of shot.

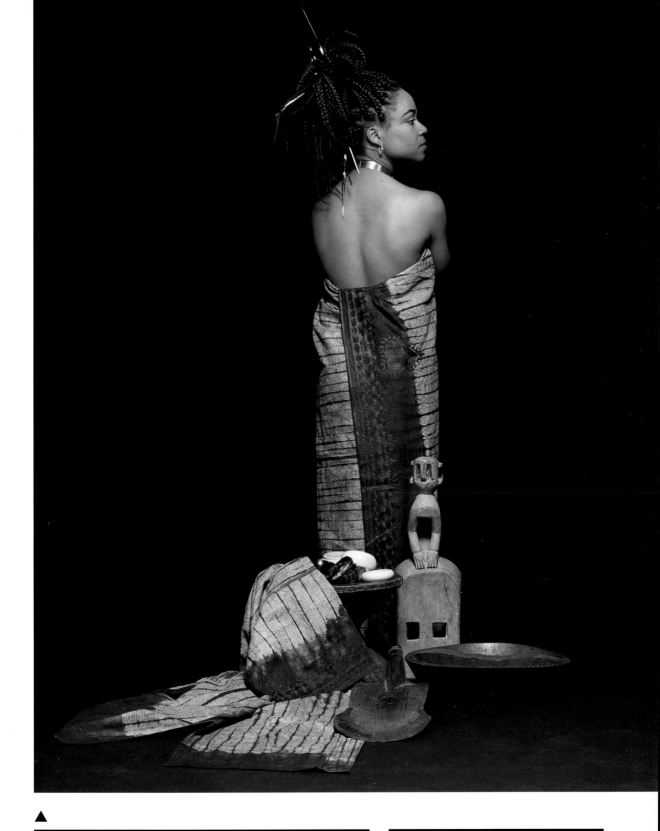

▲

The clothes and props for this otherwise bare set were provided by the client. They came from her own collection of African art and craftwork she had built up over many years. Consultation between the client and photographer refined the choice of the particular objects that would appear in each shot, based on such considerations as balance, colour and the demands of the composition generally – not forgetting the client's own specific preferences.

PHOTOGRAPHER:
John Freeman
CAMERA:
6 x 7cm
LENS:
140mm
FILM:
ISO 100

EXPOSURE:
1/30 second at f16
LIGHTING:
Studio flash x 1
(fitted with a
softbox), plus
reflector

High and low key

To determine the exposure for this low-key portrait, taken just before the subject left home to attend a formal dinner dance, the photographer took a selective light reading from the highlit side of the woman's face. After locking the exposure readings into the camera he moved back and recomposed the shot before pressing the shutter release.

THE RANGE OF TONES OR COLOURS IN A PHOTOGRAPH greatly influences its mood and atmosphere. The 'normal' or 'average' subject is often composed of a range of light through dark tones or colours, all of which the camera's light meter will try to accommodate in a single exposure. However, by taking a selective light reading, or by overriding the camera's automatic exposure controls, you can manipulate the film's response to produce an image that is predominantly dark or light. Dark-toned or coloured images are known as low-key, and light-toned ones high-key.

To put this type of technique into practice you first need to put aside the concept of 'correct' exposure – it doesn't really exist. Using a spot meter, or moving in close to the subject with your camera's averaging exposure meter, so that the meter's sensor area is filled with a dark area of the subject, will cause the camera to select a larger lens aperture and/or a slower shutter speed in the belief that it is dealing with a generally dark image. As a consequence, the lighter tones or colours of the subject and in the general scene will be recorded as being brighter than if an averaging light reading had been taken. The result will be more of a high-key photograph. Reverse this procedure and a low-key picture will result – fill the light meter's sensor area with a light colour or tone to force the camera to select a small aperture and/or a fast shutter speed.

Just how effective a high- or low-key result will be depends on the distribution of tones and colours in the subject and the general scene and how much of the picture area they occupy. If, for example, the subject is dark-haired, wearing dark clothes and is posed against a generally dark background with just small areas of highlighting, taking a shadow reading with your light meter cannot hope to result in a high-key photograph.

PHOTOGRAPHER:	FILM:
Jos Sprangers	ISO 200
CAMERA:	EXPOSURE:
35mm	1⁄60 second at f8
LENS:	LIGHTING:
80–210mm zoom (set at 105mm)	Daylight only

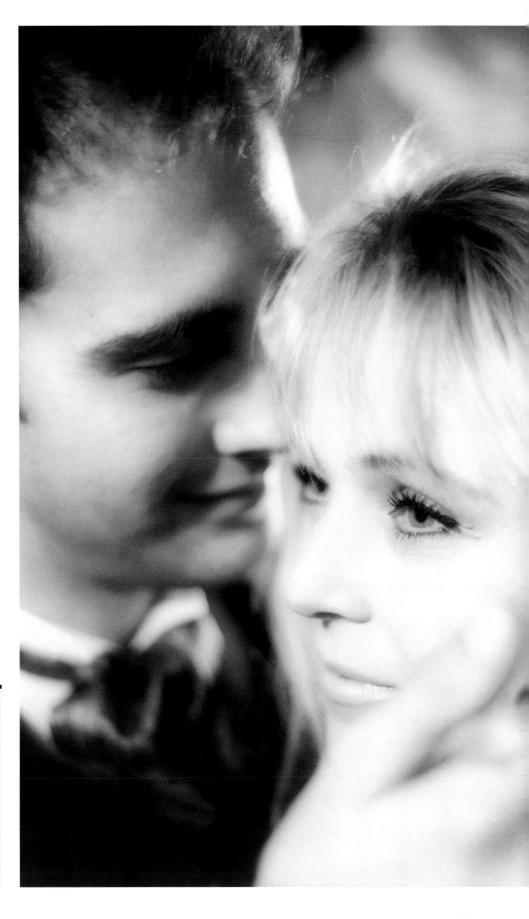

The blonde hair colouring and pale skin tones of the woman were the inspirations for this high-key portrait. The photographer lit the woman's face with direct flash from the left of the camera position and placed another light behind the pair of figures to backlight the woman's hair and create a small area of highlighting on the man's forehead. The soft-focus effect, which has the effect of making highlights spread out, was achieved by selecting a wide lens aperture, and a selective light reading was taken from a slightly shadowed area of the man's suit.

PHOTOGRAPHER:
Jos Sprangers
CAMERA:
35mm
LENS:
80–210mm zoom (set at 180mm)
FILM:
ISO 200
EXPOSURE:
$\frac{1}{25}$ second at f3.5
LIGHTING:
Studio flash x 2

Family groups

PHOTOGRAPHER:
Lesley Ann Fox
CAMERA:
6 x 6cm
LENS:
80mm
FILM:
ISO 400
EXPOSURE:
⅟₂₅ second at f8
LIGHTING:
Daylight only

WHEN PHOTOGRAPHING PAIRS AND GROUPS OF PEOPLE it is important to ensure that the arrangement of the figures ties the whole composition together. Look out for such details as the position of subjects' arms and hands, since these can lead viewers' eyes on to the next figure or direct attention completely out of the frame. Colour and tone, too, are important factors, having either a unifying or fragmenting effect on a composition – colours that create disharmony positioned too closely together, for example, may have a deleterious effect on the group as a whole, while harmonious or repeating colours or tones can act like stepping stones, taking the eye from one subject to the next.

What you most want to avoid when photographing a family group is uniformity of head height and pose. Nothing is more boring that a straight line-up of subjects with everybody's limbs organized in precisely the same way. Some seated while others stand is an obvious and far better arrangement, or look to use the setting to the best possible advantage so that you obtain a variety of subject natural-looking positions without the whole arrangement seeming contrived.

Lighting is particularly crucial with group portraits. Try to make sure that each face is lit to approximately the same intensity – unless, that is, you want

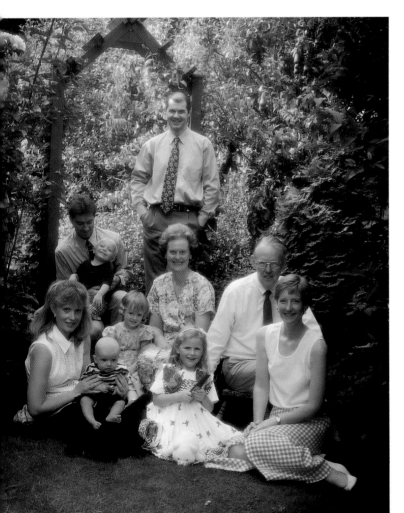

◄

Grandfather's 60th-birthday celebration was the spur for this large group portrait. The photographer sought out a shady part of the garden in which to arrange the subjects to avoid them having to squint – as they certainly would have done in the bright sunshine you can see in the background. The photographer was only too well aware of the need to work quickly because of the presence of the children, especially true with babies and toddlers, because of their short attention span.

▲

to emphasize some members and cast others into more of a supporting role in the composition. If the lighting is directional, then make sure that group members are not casting distractingly obvious shadows over each other. And if you are using artificial lighting, or supplementing natural light with, say, flash, then make sure that there is only a single dominant lighting direction – otherwise conflicting shadows may be produced, which, inevitably, will make the lighting appear artificial.

It is surprising how positively people respond to black and white when they see well-printed images, such as this one of a couple who had not been professionally photographed since their wedding years before. Part of the problem is that most film today is processed and printed by automated laboratories, but when a black and white film is treated in this way results are often, at best, indifferent.

PHOTOGRAPHER:
Lesley Ann Fox
CAMERA:
6 x 6cm
LENS:
105mm
FILM:
ISO 400
EXPOSURE:
$\frac{1}{125}$ second at f8
LIGHTING:
Daylight only

CONTACT SHEETS

An ideal way to select images from a photo session for enlargement is to have a contact sheet made. As its name implies, the slides or negatives are placed in contact with a sheet of printing paper and exposed to light. After processing, what you have is a set of images exactly the same size as the film originals. Medium format images should be large enough for you to see quite a bit of detail, but 35mm images may be too small to see comfortably without the aid of a magnifying glass. Alternatively, you can have an enlarged contact sheet produced, but this is more expensive. Bear in mind that colour balance and exposure needs to be calculated for each individual image, and so you cannot expect perfect results when many images are exposed all at the same time. But they should still be perfectly adequate for selection purposes.

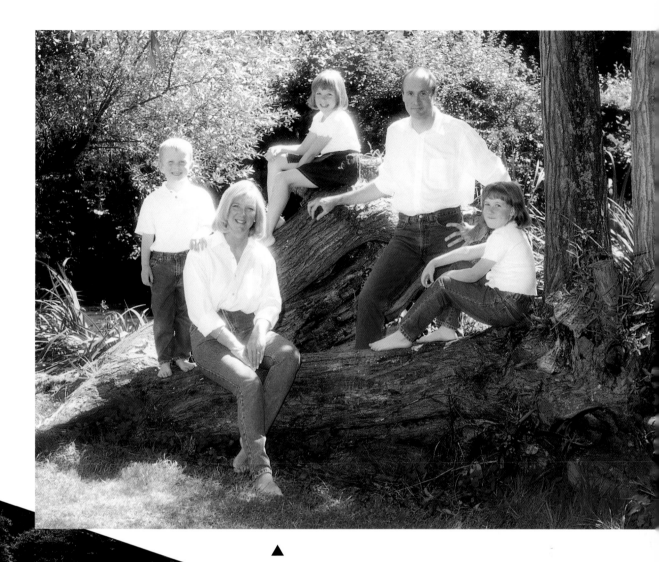

It is interesting how the photographer here has utilized natural features in the clients' garden to bring about an informally composed family group portrait containing a variety of subject poses. By arranging the different family members on and around the magnificent root system of a well-established tree she has created an essentially circular composition. This, in itself, is a powerfully unifying feature of the image, an aspect that has been reinforced by the repetition of white shirts the family members are wearing. You can see from the accompanying contact sheet that the original film image encompassed much more of the garden setting. In the end, however, the photographer decided on a more tightly cropped print for presentation to the clients.

PHOTOGRAPHER:
Lesley Ann Fox
CAMERA:
6 x 6cm
LENS:
80mm
FILM:
ISO 400
EXPOSURE:
½₅₀ second at f11
LIGHTING:
Daylight with fill-in flash

Responding to a brief

IT IS SURPRISING HOW OFTEN CLIENTS TELEPHONE OR DROP INTO A PHOTOGRAPHER'S STUDIO to commission a special occasions portrait with only the very haziest idea of the type of finished results they want. Your first job, then, is to find out as much about the particular occasion as you can. Apart from the background to the event itself, it will help to know in advance how many people are to be involved in the picture or series of pictures, what the relationship is between them all and whether a formal or informal interpretation is preferred. If the finished pictures are to be in colour, then offer some advice about the clothes that should be worn on the day of the photo session to avoid the possibility of colour clashes. If the results are to be in black and white, then explain that although some colours appear strong and distinctly different from each other when viewed normally, once they are translated into monochrome they can appear identically toned and, therefore, indistinguishable from each other. At the end of this briefing process, which in reality normally takes only a few minutes, both you and your client should have a much firmer, more realistic idea of what is likely to be achieved. On the day of the shoot, when all the personnel are assembled and you can see the material you have to work with, this is the time to talk through your ideas about composition, backgrounds, picture format and presentation.

PHOTOGRAPHER:
Jos Sprangers
CAMERA:
6 x 4.5cm
LENS:
180mm
FILM:
ISO 125
EXPOSURE:
⅟₆₀ second at f5.6
LIGHTING:
Studio flash x 2 (1 fitted with a softbox)

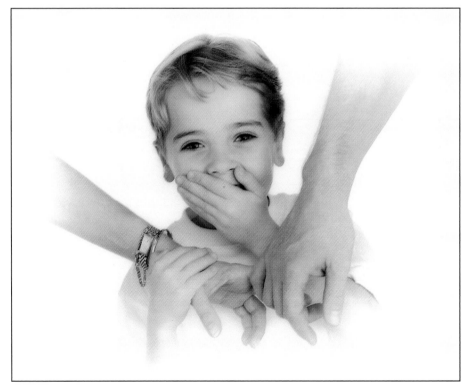

◄

The event that led to this picture was the news that the boy's mother was about to remarry and he was going to have a new father. The boy's feelings about this are obvious from the expression on his face, and the hands of his mother and father-to-be linked in front of him complete an unusual family portrait.

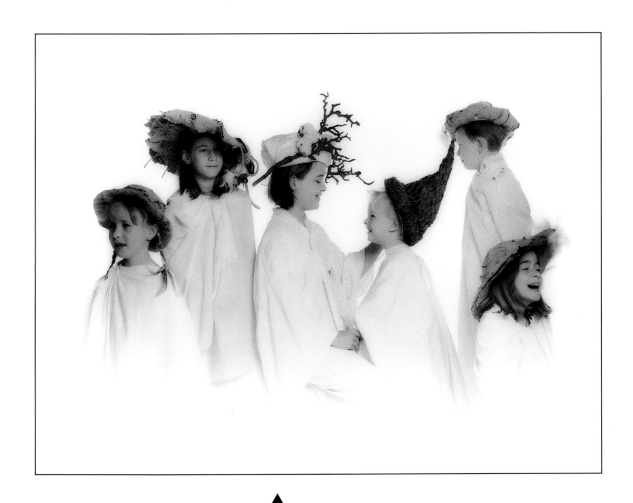

▲

VIGNETTES

To show your prints fading off gradually into a white vignette at the edges, like the ones presented here, you need to print the negatives through a piece of black cardboard with an appropriately shaped aperture cut out of the middle. The cardboard must be large enough to keep all image-forming light from the enlarger away from the edges of the printing paper; otherwise it will pick up some tone and the effect will be spoiled. Throughout the exposure, keep the cardboard moving slightly so that a sharp line of demarcation between the image area and the vignette does not appear.

These children were gathered together to have a group portrait taken after they had all appeared in a hat fashion show. To commemorate the occasion, the fashion show organizers arranged to have them taken to the studio and each was given a print afterwards. To produce a varied range of head heights, some of the children stood on boxes, and lights had to be set low enough so that illumination was not obscured by the wide hat brims some of the children were wearing.

PHOTOGRAPHER:
Jos Sprangers
CAMERA:
6 x 4.5cm
LENS:
90mm
FILM:
ISO 125
EXPOSURE:
⅟₆₀ second at f8
LIGHTING:
Studio flash x 2 (both fitted with softboxes)

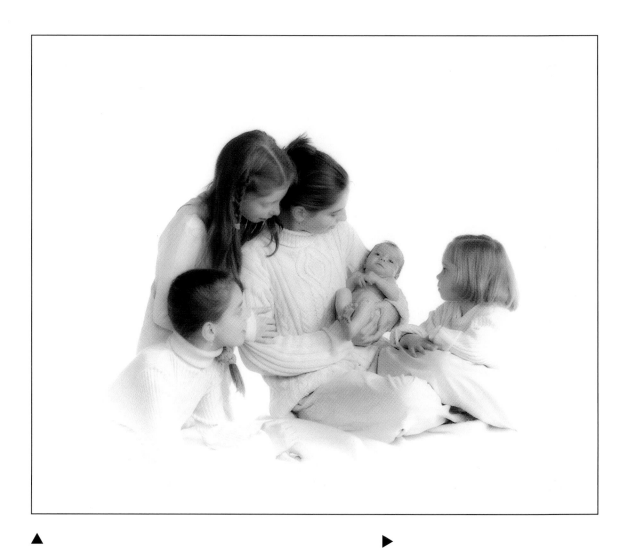

▲

With a group portrait, sometimes you leave the subjects undirected, shoot lots of film and choose the best results afterwards. At other times, however, the photographer's detached viewpoint can bring great clarity. The special event being recorded here is the birth of a new baby, a half-brother to a family of daughters. The photographer initially arranged the members of the family as you see them here, in a strongly triangular composition. This arrangement always imparts great stability and harmony to a picture. Then, to ensure that the baby was the focus of attention, the photographer directed everybody's gaze towards the infant.

PHOTOGRAPHER:
Jos Sprangers
CAMERA:
6 x 4.5cm
LENS:
90mm
FILM:
ISO 125
EXPOSURE:
⅟₆₀ second at f16
LIGHTING:
Studio flash x 3 (2 fitted with softboxes)

▶

After spending a few minutes talking to the family who are the subject of this portrait, the photographer discovered that the oldest child strongly identified with his father's work and wanted to follow him into the family business when he was older. The baby and daughter, however, because they were younger, were still at home with their mother. This simple piece of information inspired this composition, which was only one of a series of different arrangements the photographer took, but it was the parents' favourite.

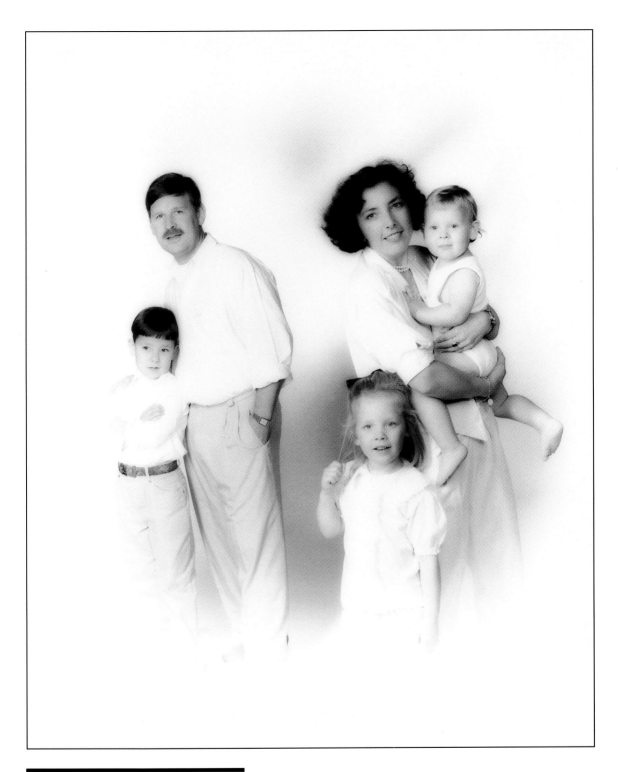

PHOTOGRAPHER:	EXPOSURE:
Jos Sprangers	**⅟₆₀ second at f11**
CAMERA:	LIGHTING:
6 x 4.5cm	**Studio flash x 2**
LENS:	**(both fitted with**
90mm	**softboxes)**
FILM:	
ISO 125	

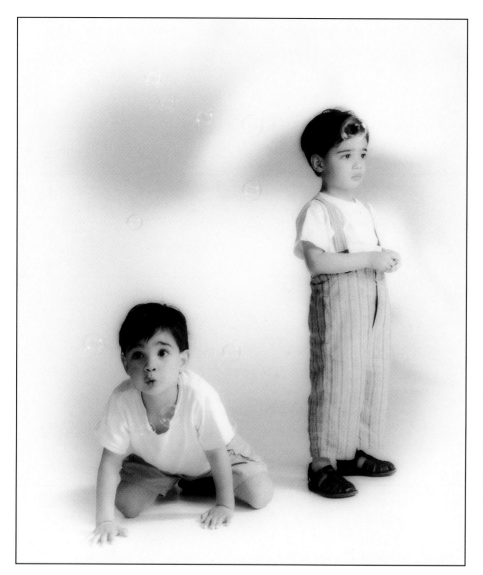

▶

This action portrait was commissioned by the cyclist's girlfriend. He is a professional racer and since she sees so little of him because of his rigorous training schedule, she wanted this photograph to hang on the wall at home. Although the subject was moving quickly past the camera position, the photographer opted to use a slow shutter speed and pan the camera in order to blur the background. The original black and white photograph was then hand coloured.

▲

Two very different personalities are evident in this double portrait. Unusually, the parents had a very firm idea of what they wanted the picture of their two boys to show when they contacted the photographer. The younger child is extraordinarily lively and dynamic – always full of energy and on the move. The older child, however, suffers with autism and is, as a result, very withdrawn. It was these two aspects of their children's characters that the photographer was instructed to capture. The bubbles make a useful prop, but take back-up shots just in case one of the soapy filaments coincides with important facial features.

PHOTOGRAPHER:
Jos Sprangers
CAMERA:
6 x 4.5cm
LENS:
120mm
FILM:
ISO 125
EXPOSURE:
⅟₆₀ second at f8
LIGHTING:
Studio flash x 2 (both fitted with softboxes)

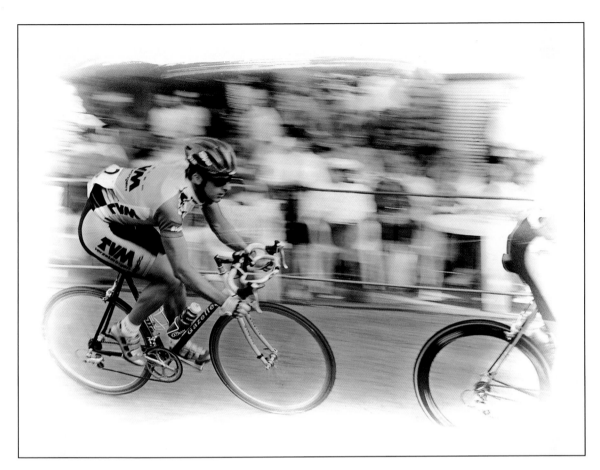

PHOTOGRAPHER:
Jos Sprangers
CAMERA:
35mm
LENS:
135mm
FILM:
ISO 400
EXPOSURE:
1⁄30 second at f11
LIGHTING:
Daylight only

HAND COLOURING

If you are thinking of hand colouring a print, it is probably best to start on a medium-large picture, such as an 8 x 10in (20 x 25cm) example. The print you choose should be light toned and printed on matte or semi-matte paper, not glossy. Fibre-based printing papers are easier to work on than resin-coated types.

• Bear in mind that you do not have to hand colour the entire print area – sometimes just areas of colour in an otherwise black and white image can be very effective.

• Soak your developed, fully fixed print in clean water and then place it, image-side upward, on your work surface and blot off surplus water.

• If the density of black silver making up the photographic image is very dense where you want the colour to show, use a brush to apply special photographic bleach (available from large photographic stores).

• When you have reduced the appearance of the silver in the areas you want to colour, rinse the print again in clean water and blot off surplus water.

Using either water-based or oil-based paints, apply colour to your chosen areas. Build the colour density up gradually, using more than one coat, rather than trying to achieve the finished appearance in one go. After every coat of paint has been added, use clean blotting paper to remove excess colour to prevent it 'bleeding' into neighbouring areas.

• If you are working with oil colours, allow at least 24 hours between coats to allow the paint to dry. A longer period may be necessary depending on the thickness of each coat.

Photographing children and babies

COMMERCIAL PHOTOGRAPHERS DEALING WITH THE GENERAL PUBLIC have to be able to interact successfully with a wide variety of subjects during the course of the 'average' year. A large measure of the satisfaction they derive from the work comes from the fact that they simply never know who is going to walk in next, or what their photographic requirements might be.

Children can be the most rewarding as well as the most testing of subjects to photograph. Often, they will be less inhibited in front of the lights than adults and they may be quite prepared to dress up and play their part – especially if you can engage their active support in making the photo session a success. Be prepared for an onslaught of questions, however. It is not unusual for them to want to know what the pieces of equipment all around them are supposed to do, why they should be positioned in a particular way, what do they look like through the camera lens, and how long the whole business is going to take. Rather than trying to 'shush' them into submission, you are more likely to win their cooperation by answering their questions as simply and fully as you can. Perhaps it might help if you were to stand in front of the lights and allow them see you through the camera's viewfinder.

USEFUL TIPS

- Children should be accompanied by a responsible adult during their entire time in the studio.
- Photo sessions with children and babies should be kept short. Their concentration span is not as great as that of an adult and they soon become tired and fractious.
- If you are using flash, fire the units a few times to allow babies to become accustomed to the sudden explosions of light. Once they have settled down again you can start the photo session proper.
- Using a zoom lens allows you to adjust subject framing and so compensate for any unexpected movements.
- Diffused or reflected light is flexible to work with since it does not rely on precise subject positioning.
- A few toys, books or games in the studio will give children something to occupy themselves with while waiting to be photographed. These could also be used as props during the actual session.
- Children will be generally more cooperative in front of the camera if you manage to make the session a fun time for them.
- With babies, fit the photo session around their normal routine. Mornings are often best because babies are naturally awake and alert at that time.

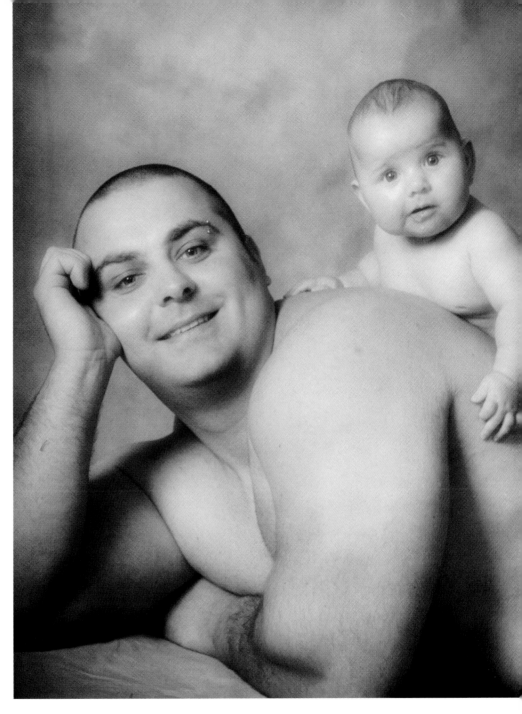

Young babies cannot support themselves in front of the camera and so have to be shown either lying down or propped up in some other way. For this baby's first portrait the father makes a convenient support. Usually, the rounded shapes of a baby are in contrast with the more angular shapes of an adult, Here, however, the baby looks like a miniature version of her father. Reflected light from the right of the camera position was used, with a smaller flash unit behind the subjects illuminating the background alone.

PHOTOGRAPHER:
Trevor Godfree
CAMERA:
6 x 4.5cm
LENS:
180mm
FILM:
ISO 125
EXPOSURE:
⅟₆₀ second at f11
LIGHTING:
Studio flash x 2 (1 fitted with a reflective umbrella)

Working with young children and babies requires a different approach, since you cannot count on their active cooperation in your endeavours – they are simply too young to understand what is going on. You will achieve a higher success rate in situations such as this by setting a very general lighting scheme and framing shots to leave more than the usual amount of space around the subject. This allows for any unexpected movements so that the resulting images do not show cropped-off arms, feet, or tops of heads. Light schemes set to produce highlights and shadows on very specific parts of the body are likely not to work unless you can guarantee a stationary subject.

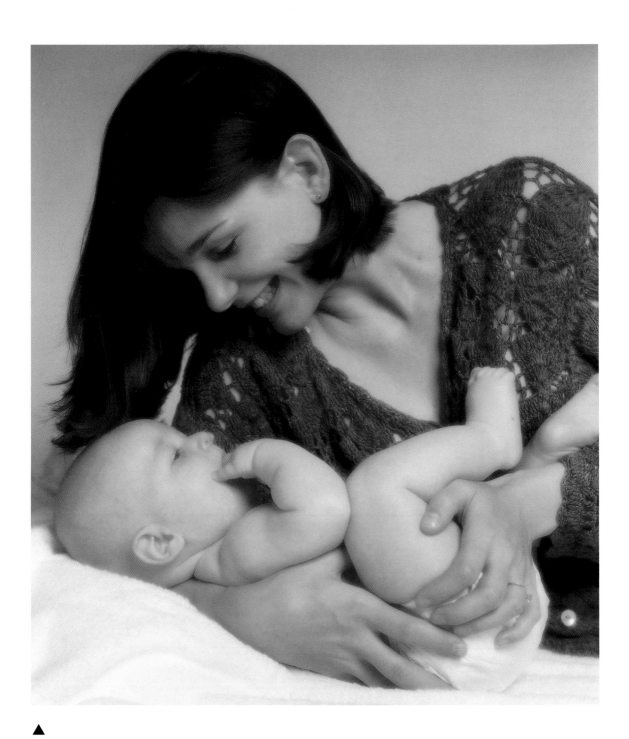

▲

Babies tend to be more expressive when they have something to respond to – here the cradling arms of a little boy's mother. Surrounding colours are best muted so that they do not compete for attention, so the mother's top is a plain, dark grey to offer some tonal contrast, while a white towel underneath and white paper for the background complete the setting.

PHOTOGRAPHER: **Lesley Ann Fox**	FILM: **ISO 160**
CAMERA: **6 x 6cm**	EXPOSURE: **⅟₆₀ second at f8**
LENS: **80mm (plus diffusing filter)**	LIGHTING: **Studio flash (fitted with softbox)**

110

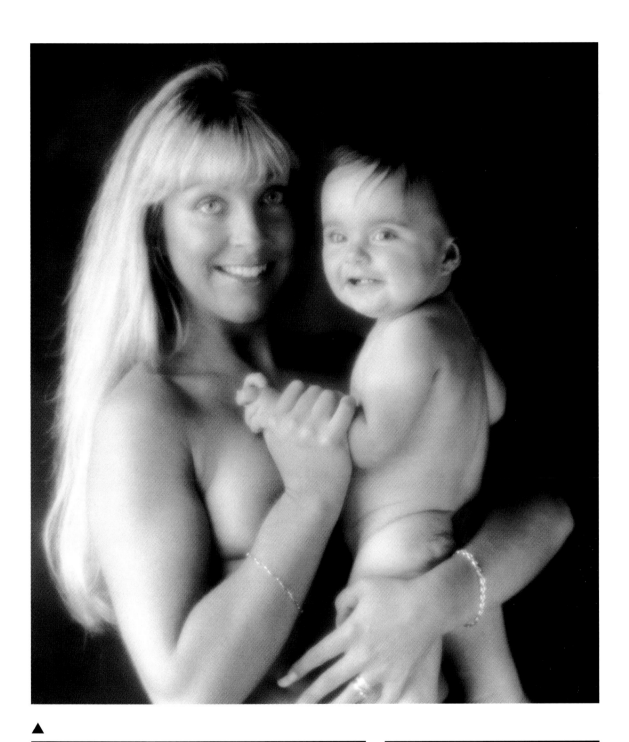

▲

This image is from a photo session using both black and white and colour film stock, showing the baby with and without her mother. To provide adequate lighting coverage, a flash unit fitted with a large softbox was positioned to the left of the camera and a reflector was placed on the right-hand side to return light spilling past the subjects and prevent shadows becoming too dense. Fill-in flash was from a frontally positioned unit fitted with a brolly.

PHOTOGRAPHER:	EXPOSURE:
Lesley Ann Fox	⅟₆₀ **second at f11**
CAMERA:	LIGHTING:
6 x 6cm (plus diffusing filter)	**Studio flash x 2 (1 fitted with a softbox and 1 with a reflective umbrella)**
LENS:	
180mm	
FILM:	
ISO 125	

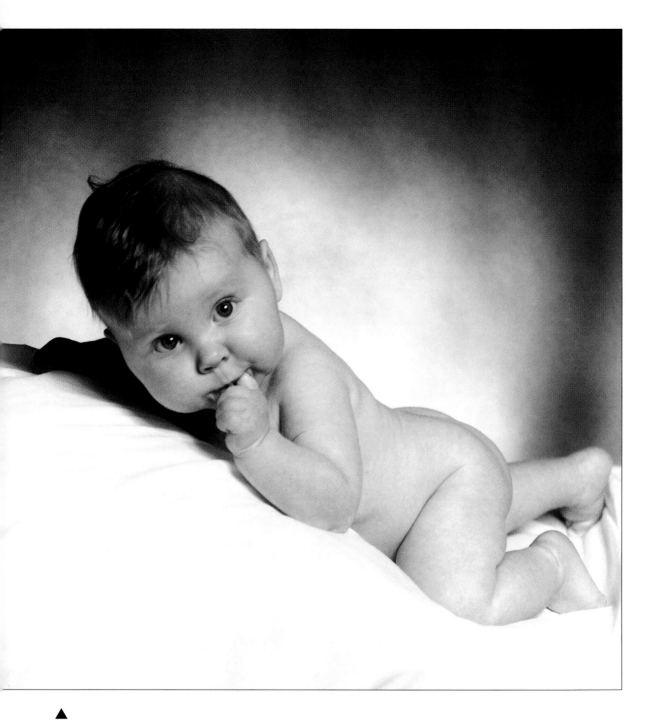

▲

Without the supporting arms of a parent you need to raise a baby up to give you a variety of shooting options. Here the photographer covered a large, soft cushion with a clean white sheet to give the child something to lean against. The cushion was placed on a table in order to increase the shooting height. If you don't raise the child up, you – and your lighting stands – will have to come down almost to floor level, which is not the most comfortable working position. The highlight behind the child was created by a light shining through the canvas backdrop from behind.

PHOTOGRAPHER:
Lesley Ann Fox
CAMERA:
6 x 6cm
LENS:
80mm (plus diffusing filter)
FILM:
ISO 125

EXPOSURE:
⅟₆₀ second at f8
LIGHTING:
Studio flash x 2 (1 fitted with reflective umbrella)

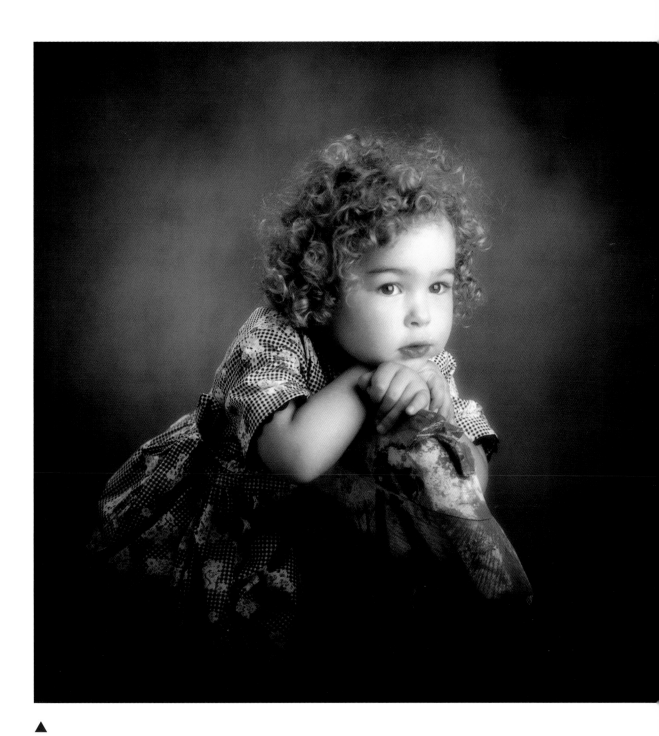

▲

The star of this photo session is a little girl celebrating her fourth birthday with a session at the photographer's studio. She was old enough to understand what was going on and was a very cooperative subject in front of the camera. Of all the diversions the photographer had at his studio for children to play with, it was the rocking horse that she fell in love with and wanted included with her in her birthday photograph.

PHOTOGRAPHER:	EXPOSURE:
Rudi Fransens	**⅟₆₀ second at f11**
CAMERA:	LIGHTING:
6 x 6cm	**Studio flash x 2 (1**
LENS:	**fitted with a**
90mm	**softbox)**
FILM:	
ISO 200	

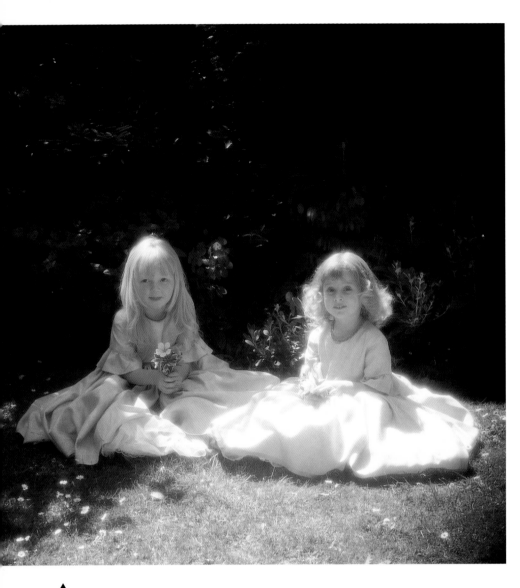

A shy but very happy seven-year-old girl is shown in this portrait, which was taken to commemorate her first communion. The bouquet of flowers, which she had with her in church that morning, adds an extra level of interest to the portrait, as well as giving her something natural to do with her hands. Although only a seemingly small point, making the subject's hands appear relaxed is one of the difficult aspects of formal portrait photography.

Two best friends dressed up and ready to go to a party proved to be an irresistible opportunity for a special occasions photograph in the back garden. Their dresses are identical because they are bridesmaids' outfits the youngsters wore the previous summer. The light for the shot is entirely natural daylight, essentially shining from behind the subjects. This meant that the exposure reading had to be selectively taken from their skin tones. A general light reading would have produced heavy shading on their faces. During printing, the surrounding vegetation was vignetted to increase the contrast between the subjects and background.

PHOTOGRAPHER:
Lesley Ann Fox
CAMERA:
6 x 6cm
LENS:
80mm
FILM:
ISO 400
EXPOSURE:
½₅₀ second at f11
LIGHTING:
Daylight only

PHOTOGRAPHER:
Anne Kumps
CAMERA:
6 x 4.5cm
LENS:
120mm
FILM:
ISO 200

EXPOSURE:
⅟₆₀ second at f8
LIGHTING:
Studio flash x 2 (both fitted with soft boxes)

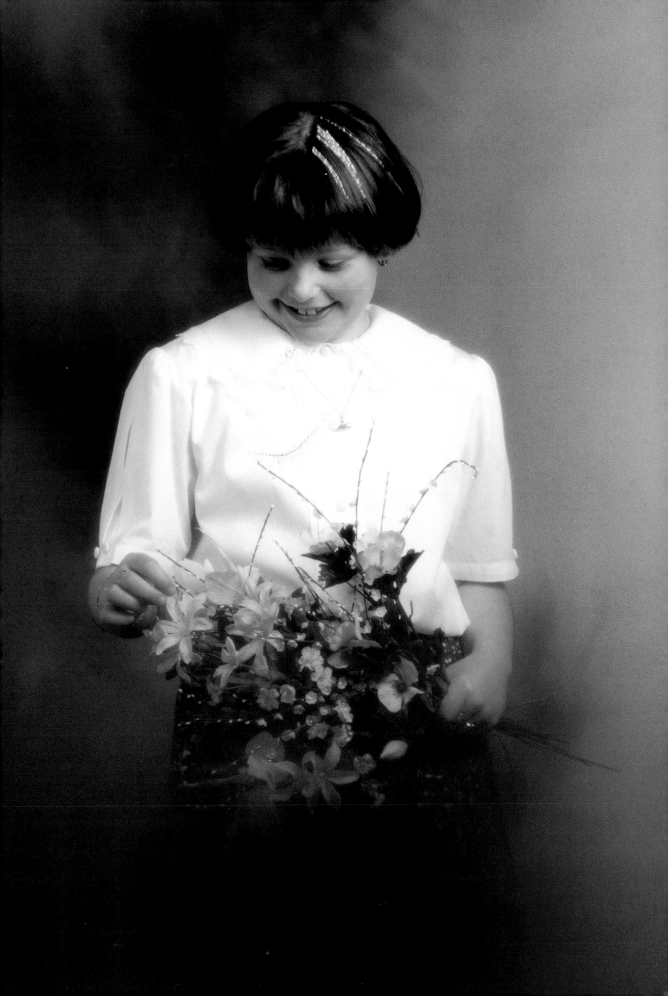

▲

A 'make-over' party for a group of school friends proved ideal for an opportunistic photo session. All that was necessary was the addition of a little eyeshadow, some lipstick and an old straw hat. The lighting scheme was simple – one flash unit with softbox and a reflector on the opposite side to lessen the contrast between the lit and unlit sides. Bear in mind when setting lights that you have to get them down low enough to prevent the brim of the hat casting shadows over the face and obscuring details.

PHOTOGRAPHER:	FILM:
Lesley Ann Fox	ISO 200
CAMERA:	EXPOSURE:
6 x 6cm	⅟₆₀ second at f8
LENS:	LIGHTING:
135mm (plus diffusing filter)	Studio flash x 1 (fitted with a softbox)

▲

This attractive portrait was taken as part of a specially
commissioned set as a surprise 50th-birthday present for the boy's
step-father. The day was bright but overcast and so the
photographer took a selective light reading directly from the
subject's face to ensure correct exposure. It is often easier to get
children more involved in the session when they are outside in the
garden or on location than in the confines of a studio, where you
need to exercise some control to prevent accidents or damage
to equipment.

PHOTOGRAPHER:	FILM:
Lesley Ann Fox	ISO 400
CAMERA:	EXPOSURE:
6 x 6cm	$\frac{1}{125}$ second at f8
LENS:	LIGHTING:
80mm	Daylight only

Subject and setting

EACH PORTRAIT COMMISSION HAS TO BE CONSIDERED ON ITS OWN MERITS. Depending on the intention behind the photograph, a very austere, starkly plain setting might be appropriate for the subject or subjects. When working in the studio, this is often the best option, since elaborate, artificial backdrops do not usually work well unless they are very professionally, and expensively, produced. When working on location, however, it is the domestic or work environments of the subjects that often adds immeasurably to the level of understanding a viewer can have of the people depicted. All of us invest something of our personality in our surroundings, and it is these insights that can be of unending interest when recorded in a photograph.

You do yourself no good by taking on a commission that you are not equipped to handle. If you are shooting in large, elaborate settings, as you can see in some of the shots here and on following pages, and don't have, for example, adequate artificial lighting of your own, then either borrow or hire additional units. Alternatively, move the subject into a smaller setting, one that you can adequately light with what you have at your disposal, or confine your subject to a small area of a larger room. If you are using flash, you may well be able to supplement your lighting unit(s) with natural daylight, depending on the time of day and the orientation of windows, doors and so on.

▶

PHOTOGRAPHER:
John Freeman
CAMERA:
5 x 4in
LENS:
90mm
FILM:
ISO 64
EXPOSURE:
⅕₀ second at f22
LIGHTING:
**Studio flash x 2
(both fitted with
softboxes)**

Summoned to the clients' home to record a very special occasion, the photographer was confronted by a painted ceiling that the couple had spent three years in creating. They had just finished their mammoth labour and wanted the moment recorded. Although the subjects of the painted scenes are obviously biblical, the faces are those of their family members. One studio flash unit was used to light the ceiling, while a second was directed at the subjects.

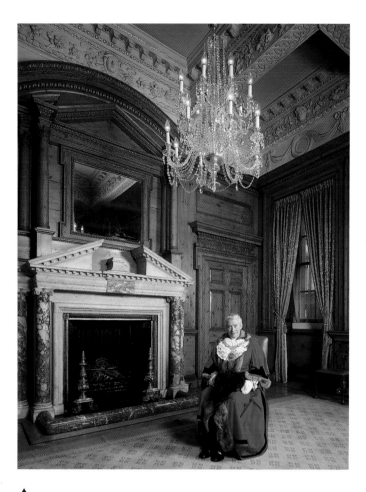

This formal portrait was commissioned by the subject on his retirement as Lord Mayor of London, and he is seen in full ceremonial regalia in one of the magnificent reception rooms that form part of his residence at Mansion House. By choosing a camera angle that restricted the view of the room, the photographer could get away with using only two lights – one studio flash was directed up into the ceiling and the other was used to the right of the camera position to illuminate the subject and the fireplace behind him.

PHOTOGRAPHER:
John Freeman
CAMERA:
5 x 4in
LENS:
90mm
FILM:
ISO 100
EXPOSURE:
⅕ second at f16
LIGHTING:
Studio flash x 2 (both fitted with softboxes)

PHOTOGRAPHER:
John Freeman
CAMERA:
5 x 4in
LENS:
75mm
FILM:
ISO 100

EXPOSURE:
⅛ second at f8
LIGHTING:
Studio flash x 2 (both fitted with softboxes)

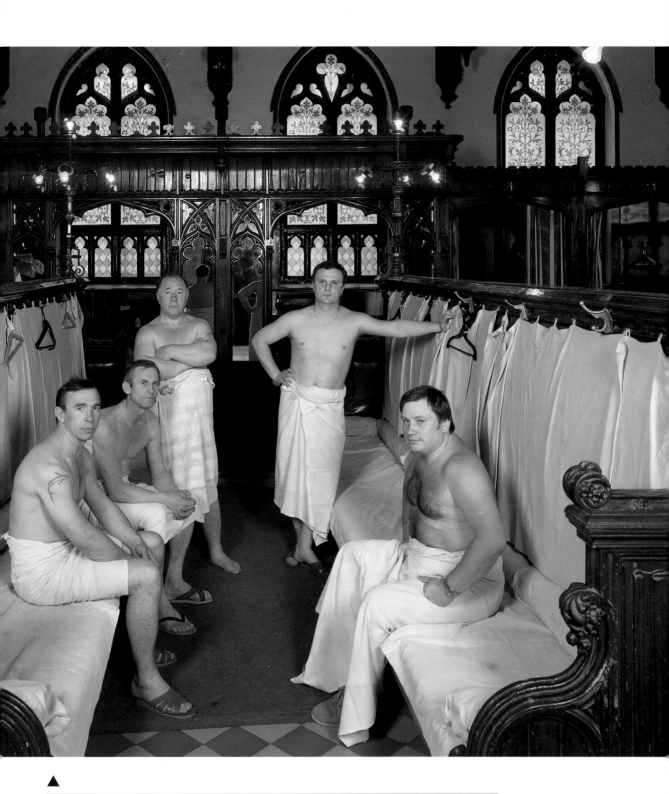

▲

The stained glass, cast brass fittings and carved wooden ornamentation speak of an earlier age, but the public steam baths shown here are still part of everyday life for many people in Moscow. The subjects depicted all work at the steam baths and wanted this group portrait taken so that all could have a print made. A slow exposure was chosen to accommodate the artificial light, which was the predominant illumination, and to allow the weak daylight outside shining through the coloured glass to register on the film. A 'normal' shutter speed with electronic flash of, say, ⅟₆₀ second would have left the background in featureless shadow.

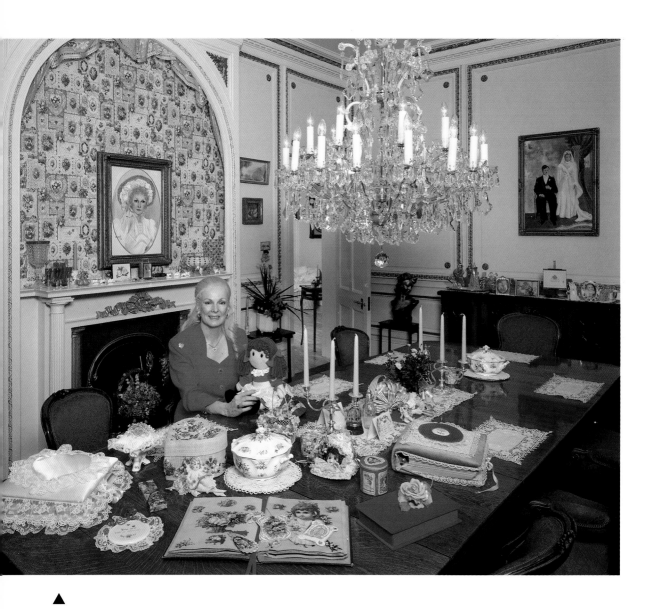

▲

In recognition of a record-breaking fund-raising season, the head of a children's medical charity wanted this portrait taken. The photographer decided on a slow exposure to allow the weak lights from the chandelier to record on the film and so add a warm glow to the scene. He also decided to open the far door to prevent the room appearing too enclosed. This meant that the hallway had to be lit as well as the dining room in which the subject was posed.

PHOTOGRAPHER:
John Freeman
CAMERA:
5 x 4in
LENS:
90mm
FILM:
ISO 100
EXPOSURE:
⅛ second at f11
LIGHTING:
Studio flash x 2 (both fitted with softboxes), plus an additional flash unit in the hallway

▲

With only a few minutes to spare, the then Speaker of the House of Commons did not have time to wait for lights to be set and tested. Instead, the photographer was given access to this room in the Palace of Westminster, London, half an hour beforehand. When the Speaker arrived, the session took just ten minutes. In order to do justice to the setting, one studio flash was used to light the ceiling, while two other units were directed at the subject – the angles of their heads calculated so that their light spilled past the Speaker to illuminate the surroundings without casting dense or hard-edged shadows.

PHOTOGRAPHER:	EXPOSURE:
John Freeman	**⅕ second at f22**
CAMERA:	LIGHTING:
5 x 4in	**Studio flash x 3**
LENS:	**(all fitted with**
90mm	**softboxes)**
FILM:	
ISO 100	

Framing the subject

PHOTOGRAPHER:
John Freeman
CAMERA:
5 x 4in
LENS:
90mm
FILM:
ISO 100
EXPOSURE:
¹⁄₆₀ second at f11
LIGHTING:
**Studio flash x 2
(both fitted with
softboxes)**

JUST AS THE PICTURE EDGES CONTAIN THE OVERALL COMPOSITION, so you can look for features in the environment or setting that you can use to contain the principal subject of a photograph. Using internal frames, as long as they are not over-contrived, can be an affective way of drawing attention to what you consider to be the most important part of the image. Once you have established this key area, move around the subject looking through the camera's viewfinder, perhaps altering focal length, too, until you see the other elements in the scene slipping into a pleasing and effective relationship with the subject.

Doorways, windows, columns and other architectural features are just some examples of potential framing devices you can use indoors, while, outdoors, you could use a wide range of features, natural or artificial, as well as contrasting or harmonizing areas of colour or tone. However, depending on the composition, equally effective frames could be the subject's own hair, hat, scarf or beard if the portrait is close-up. But bear in mind

Taken on a stairway at Westminster School, which, in parts, dates back to the 14th century, this picture – part of a series of double portraits – was commissioned to commemorate the boys' last day there as students. They had just received their examination results and knew they were on their way to university. The boys' poses (framed between pillars at the top of the stairs) are formal, in keeping with the setting in which they are seen. Lighting a space as large as this, however, is always difficult when on location, when even the most powerful accessory flash would be inadequate. Here, the photographer positioned one portable studio flash pointing upwards at the wall to bounce light on to the ceiling, while a second flash unit was directed straight at the subjects from near the camera position.

▶

Here, the photographer framed the boys in the draped recess of a tall window. His idea was to produce a symmetrical composition, with picture balancing picture and wall light balancing wall light. The technical problem presented in this arrangement was how to equalize the light indoors with that in the street outside. The first step was to take a light reading for the outdoor scene and then to calibrate the single studio flash used indoors to produce the same exposure. The light had to be positioned off-centre in order to avoid reflections from the flash showing in the glass panes.

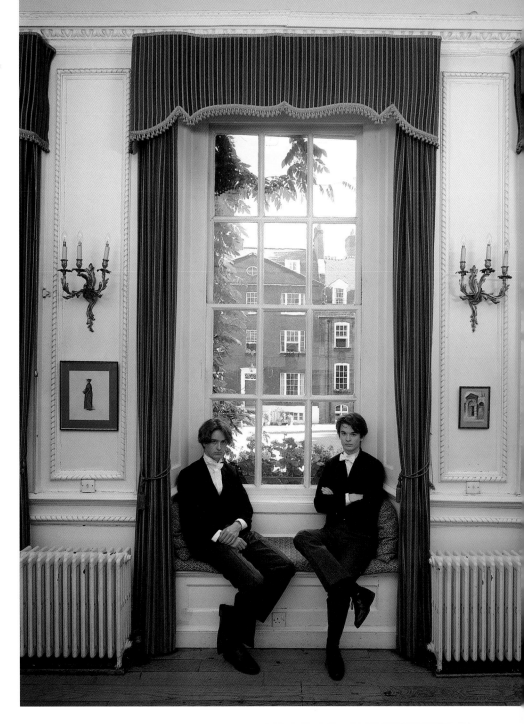

that even a pronounced frame may be the result of viewing the scene from a very specific angle. If you were to move around the setting to a new shooting position, that same frame may simply disappear or no longer relate properly to the subject.

PHOTOGRAPHER:	EXPOSURE:
John Freeman	**⅛ second at f22**
CAMERA:	LIGHTING:
5 x 4in	**Studio flash x 1**
LENS:	**(fitted with a**
150mm	**softbox)**
FILM:	
ISO 100	

This close-up portrait of an internationally renowned musical instrument maker has the potential to be used as a publicity picture. Half of the subject's face is framed by his beard and half by the lute he had just completed. The body and neck of the instrument effectively prevent your eye from looking past the subject. Only one studio flash unit was used, to the right of the camera position, but a reflector was positioned on the opposite side to return enough light to prevent the shadows becoming over dense.

PHOTOGRAPHER:
John Freeman
CAMERA:
6 x 6cm
LENS:
150mm
FILM:
ISO 64
EXPOSURE:
⅟₆₀ second at f16
LIGHTING:
Studio flash x 1 (fitted with a softbox), plus reflector

There is often a touch of humour woven into the composition when photographers take pictures of other photographers – in this shot, Terence Donovan. The symmetry of the book-ends framing the subject has been amplified by the fists-together pose of the subject and the choice of camera position, which shows the subject's hands precisely in the gap between the book-ends. If a general light reading had been taken, the window light would have over-influenced the meter and reduced the subject to a silhouette. To counter this, the photographer used hand-held accessory flash to one side in order to keep as much light off the reflective window panes as possible.

PHOTOGRAPHER:
John Freeman
CAMERA:
6 x 6cm
LENS:
150mm
FILM:
ISO 64
EXPOSURE:
⅛₂₅ second at f8
LIGHTING:
Accessory flash and daylight

5

Traditional white wedding

ONE OF THE MOST POPULAR FORMS OF WEDDING RITUAL in Christian societies is the white wedding. Although, like the Christmas tree, the elaborate white gown worn by the bride is a relatively recent innovation, it has acquired the air of an age-old tradition and has been successfully transplanted to many parts of the world. The popularity of the ceremony in different countries and cultures means that it varies greatly in its specific details, but, nevertheless, white weddings usually follow a predictable format. This is not to say that your approach can be formulaic, since every bride and groom requires tailor-made photographic coverage of their 'big day'. To this end, it is best to have at least one meeting with the couple beforehand in order to find out their specific picture requirements.

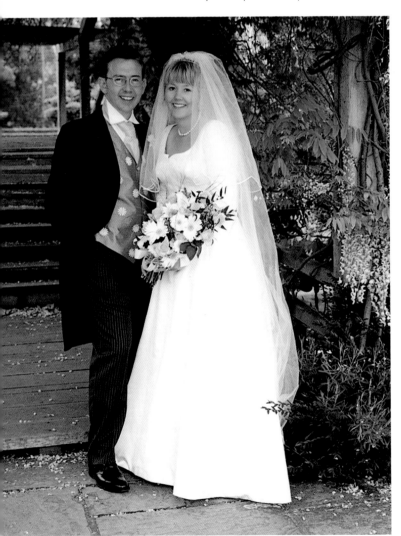

A picture such as this can be taken on the day of the wedding, after the ceremony itself, but it is a good idea to have a formal photo session a few days before just in case of the weather is not kind to you on the actual day. There is a superstition that the groom should not see the bride in her gown before the wedding ceremony, but even if this is not a problem the dress may not be ready until the last minute and the groom's formal attire, which is often hired, may not be available. This is the type of detail that has to be sorted out well in advance so that you are all working to the same timetable.

PHOTOGRAPHER:	EXPOSURE:
Majken Kruse	**$\frac{1}{125}$ second at f11**
CAMERA:	LIGHTING:
6 x 4.5cm	**Daylight and**
LENS:	**accessory flash**
80mm	
FILM:	
ISO 200	

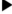

This simple photograph of the young bridesmaids makes a charming portrait. The photographer has chosen the surroundings well – the massed blooms in the flower beds coordinating with the posies the girls are holding as well as with their dresses. Try to take pictures such as this as early in the day as possible – young girls in white dresses don't usually stay clean for very long. A moderate long lens and a wide lens aperture has taken just enough of an edge off the background to prevent it intruding.

PHOTOGRAPHER:	FILM:
Majken Kruse	**ISO 200**
CAMERA:	EXPOSURE:
6 x 4.5cm	**½₅₀ second at f4**
LENS:	LIGHTING:
120mm (plus soft-focus filter)	**Daylight only**

Traditionally, the groom arrives before the bride at a church wedding. This gives the photographer an opportunity to shoot some of the principal participants to help produce a well-rounded portfolio of pictures. Here, the groom is in the middle of this group, flanked by his best man and his ushers. Always look for natural frames in the environment within which you can pose your subjects to provide extra interest and give compositions a sense of coherence. The groom, who is often nervous this close to the start of the ceremony, may appreciate the distraction of working with the photographer, but bear in mind that his nerves may be a little frayed.

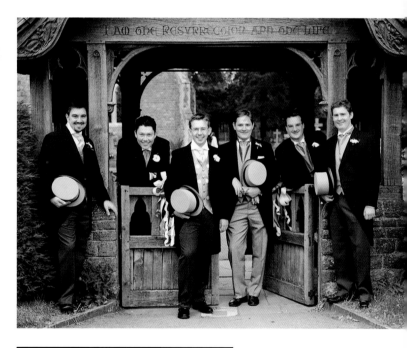

PHOTOGRAPHER:	FILM:
Majken Kruse	**ISO 200**
CAMERA:	EXPOSURE:
6 x 4.5cm	**⅟₆₀ second at f11**
LENS:	LIGHTING:
80mm	**Daylight and accessory flash**

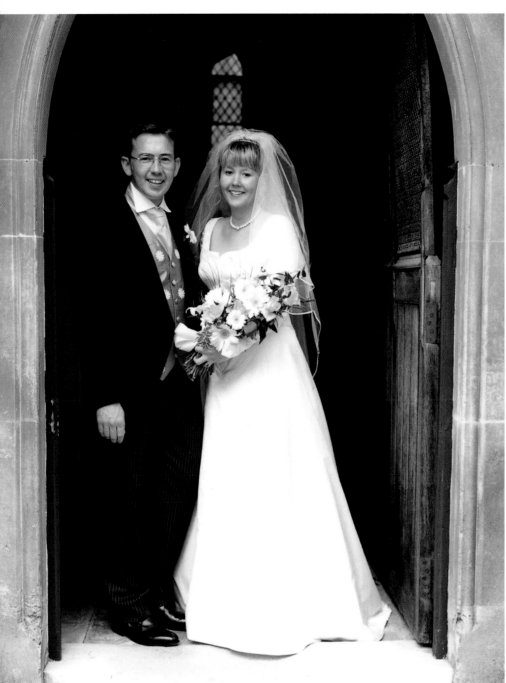

Check beforehand if photography is allowed during the ceremony – some churches have no objection, but others do – especially if flash is required in order to compensate for low levels of natural lighting. No matter what, this type of image, of the bride and groom leaving the church after their wedding, is a 'must'. Don't allow your camera's exposure meter to be influenced by a very dark background, such as the interior of the building here, otherwise subjects will be massively overexposed. If your camera has a spot metering option, the exposure variation in this scene should not be a problem. If it does not, move in close, take a selective reading from the subjects' skin tones and then move back and re-compose the shot.

PHOTOGRAPHER:
Majken Kruse
CAMERA:
6 x 4.5cm
LENS:
120mm
FILM:
ISO 200

EXPOSURE:
⅟₂₅ second at f8
LIGHTING:
Daylight and accessory flash

Things will go a lot smoother on the big day if you have an agreed shot-list – bride, groom, and groom's parents/bride's parents; bride, groom and bridesmaids; groom, best man and ushers; and so on. Bear in mind that with the release of tension after the ceremony there is often a fair degree of confusion, so you may have to assert yourself to make sure you get your job done.

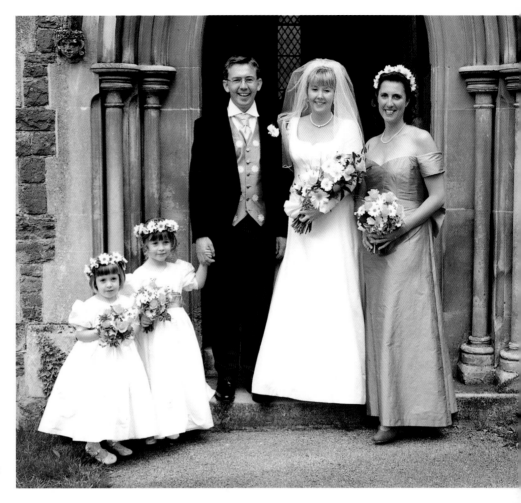

PHOTOGRAPHER:
Majken Kruse
CAMERA:
6 x 4.5cm
LENS:
80mm
FILM:
ISO 200
EXPOSURE:
⅟₆₀ second at f5.6
LIGHTING:
Daylight only

PHOTOGRAPHER:
Majken Kruse
CAMERA:
6 x 4.5cm
LENS:
120mm
FILM:
ISO 200
EXPOSURE:
⅟₆₀ second at f8
LIGHTING:
Daylight and accessory flash

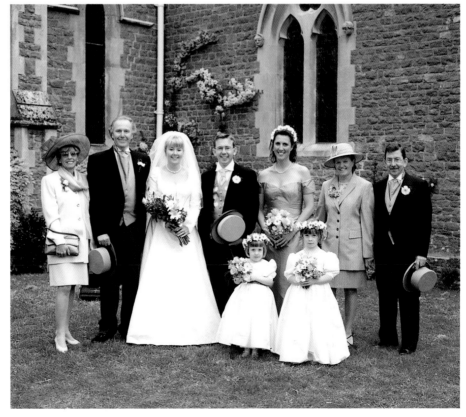

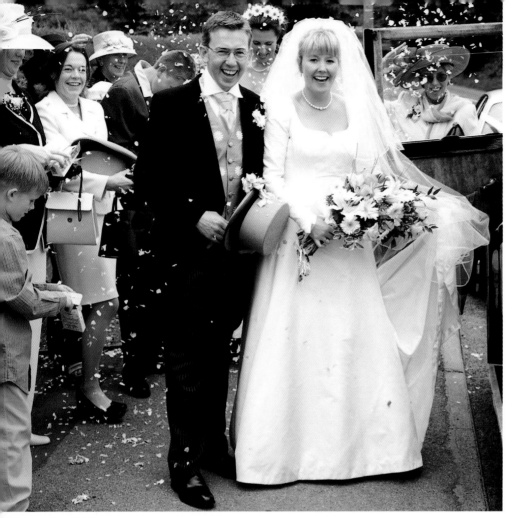

You will need to get to the front of the scrum to record pictures of the bride and groom leaving the church for their journey to the reception. Take more pictures than you might normally in a situation like this because you never know if, for example, a stray piece of confetti has floated in front of your subject's face or a hand from somebody nearby has strayed in front of your lens at the critical moment.

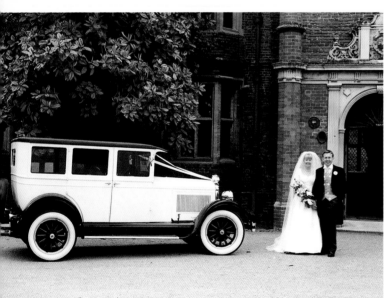

▲

The transport from the church to the reception is often something a bit special – a horse-drawn carriage, stretch limousine, or, as here, a vintage car.

PHOTOGRAPHER:
Majken Kruse
CAMERA:
6 x 4.5cm
LENS:
80mm
FILM:
ISO 200
EXPOSURE:
1/125 second at f8
LIGHTING:
Daylight only

PHOTOGRAPHER:
Majken Kruse
CAMERA:
6 x 4.5cm
LENS:
80mm
FILM:
ISO 200
EXPOSURE:
1/125 second at f11
LIGHTING:
Daylight and accessory flash

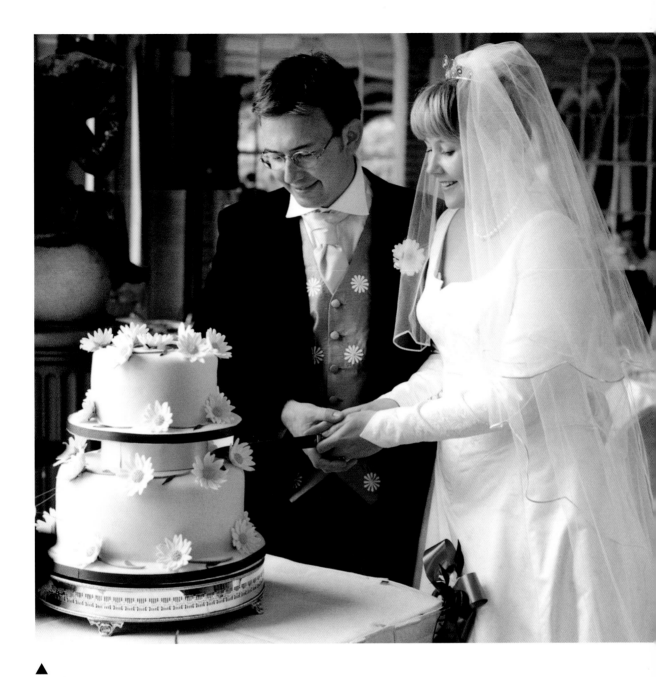

▲

The reception gives you an opportunity to take some candid, informal shots of guests. Again, refer to your list drawn up with the clients to make sure you get a picture of those especially important to them. However, there is one picture that has to form part of the wedding picture portfolio – the cutting of the cake. This is usually a set-piece picture taken at any convenient moment you can draw the bride and groom aside from their guests. Take all the time you need to make sure the bride's gown and veil are well arranged and that the lighting is just as you want it. If there is no window light available – not a problem for this image – you will have to use supplementary lighting to boost levels.

PHOTOGRAPHER:	FILM:
Majken Kruse	**ISO 200**
CAMERA:	EXPOSURE:
6 x 4.5cm	**⅙₀ second at f5.6**
LENS:	LIGHTING:
80mm	**Daylight only**

Sikh wedding highlights

DEPENDING ON THE REQUIREMENTS OF INDIVIDUAL WEDDING COUPLES, photographic coverage can be comprehensive or it can just capture some of the more memorable highlights. There are different ways of negotiating the scope and, therefore, the cost of a wedding portfolio, but a common method is to agree on the number and size of pictures that will make up the final presentation, which can be selected from enlarged contact sheets or small en-prints of all the material taken on the day. Also, find out whether or not the couple want the pictures loose, fitted into special mounts or made up into a traditional album. And to avoid any possibility of disagreement, agree in advance the cost of any duplicate prints that are ordered by the family and friends. Often, if multiple copies of particular originals are required, it is usual to offer

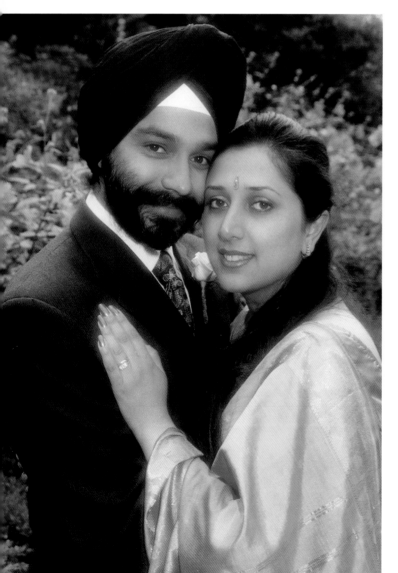

◄

This stage of the coverage of a wedding is optional, although many couples want at least some formally and informally posed portraits taken to celebrate the period of their engagement. When posing a formal portrait such as this, it is the care you take in getting the small details just right that determine the picture's success – even the position of the woman's fingers as they rest on her fiancé's chest is significant, as is the arrangement of her long hair and the folds in the silk of her gown.

PHOTOGRAPHER:
Ami Ghale
CAMERA:
35mm
LENS:
90mm (plus soft-focus filter)
FILM:
ISO 200

EXPOSURE:
⅟₆₀ second at f5.6
LIGHTING:
Daylight and reflected accessory flash

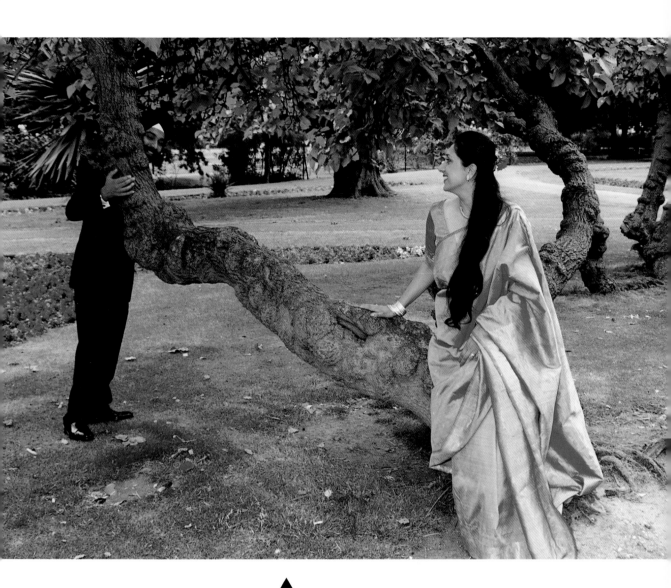

▲

a discount on the unit cost of each print. This should not reduce your profit margin, since you will be increasing the number of prints being ordered

The pictures on these pages, and those that follow, are just a selection of those taken of a traditional Sikh wedding. Although the coverage of the engagement, ceremony and reception was extensive, the selection shown here illustrates how a small number of well-conceived, excellent-quality images can capture the atmosphere of what is, for the couple, one of the most significant days of their lives.

Here the photographer has utilized features in the setting chosen for the photo session as props to produce a relaxed and informal engagement photograph. The bride-to-be, resting against the base of the tree, acts as the anchor point for the composition and the shape of the near-horizontal tree trunk acts as a powerful lead-in line, reinforced by the direction of her gaze, taking the viewer's attention right to the groom.

PHOTOGRAPHER:
Ami Ghale
CAMERA:
35mm
LENS:
35mm
FILM:
ISO 200
EXPOSURE:
⅟₆₀ second at f16
LIGHTING:
Daylight only

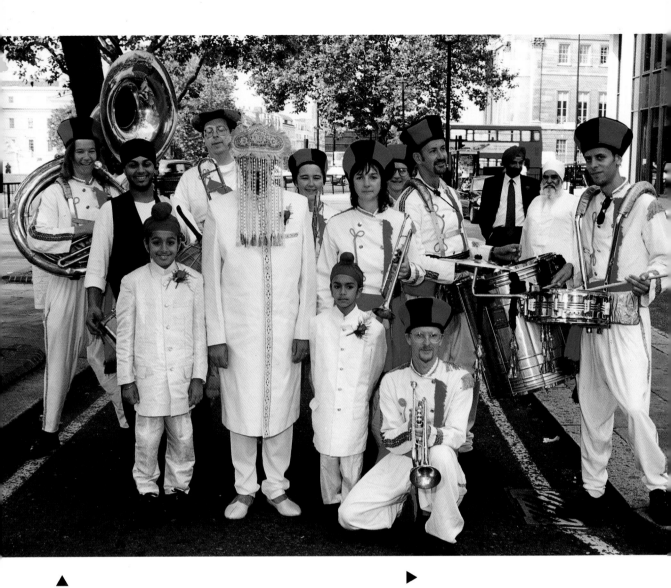

▲

Both a colourful scene and an important part of the wedding ceremony is seen here, as the groom, beaded veil in place, enters the hall where the wedding is to take place, accompanied by a troupe of musicians. The shade cast by the tree under which the group is posed was a little too heavy, and so the photographer increased light levels locally using an accessory flash mounted on a special bracket at the side of the camera to avoid the problem of 'red-eye'. Red-eye occurs most often when the flash is positioned too close to the lens axis and is caused by light reflecting from the veins at the back of the subject's eyes.

| PHOTOGRAPHER: |
| Ami Ghale |
| CAMERA: |
| 35mm |
| LENS: |
| 35mm |
| FILM: |
| ISO 200 |
| EXPOSURE: |
| ⅟₆₀ second at f16 |
| LIGHTING: |
| Daylight and accessory flash |

▶

Welcoming guests to the wedding reception are traditional musicians. Although shots such as this probably will not be discussed at the photo-planning stage, use your initiative whenever a good picture opportunity occurs.

PHOTOGRAPHER:	FILM:
Ami Ghale	ISO 200
CAMERA:	EXPOSURE:
35mm	⅟₆₀ second at f11
LENS:	LIGHTING:
90mm	Accessory flash

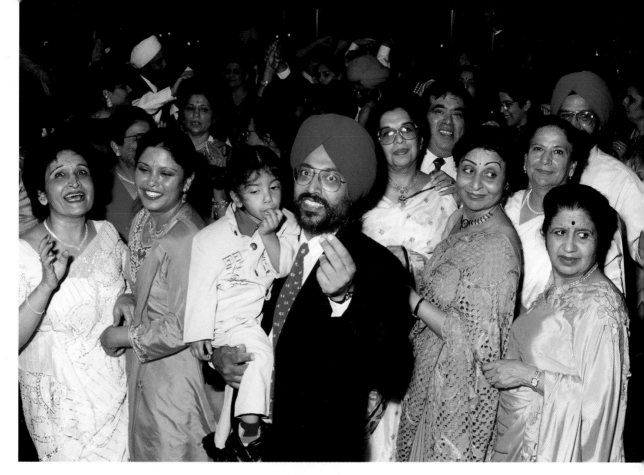

On the dance floor after the wedding ceremony, the photographer has gathered together close family members of the bride and groom for an informal group portrait. Flash fall-off is evident in the shot, but the photographer ensured that the spread of light from the flash was sufficient to encompass all the important members of the shot. The underlit figures seen dancing in the background add hugely to the interest and atmosphere of the image while not taking attention away from the foreground group.

PHOTOGRAPHER:	FILM:
Ami Ghale	**ISO 200**
CAMERA:	EXPOSURE:
35mm	**⅟₆₀ second at f11**
LENS:	LIGHTING:
28mm	**Accessory flash**

▲

It is important that a family member or friend is available to point out to the photographer all those people agreed at the planning stage who must for one reason or another be included in the photo coverage. It is then the photographer's job to pose them quickly and to get them to respond positively to the camera. You must work speedily and professionally at the reception, since your subjects are there to celebrate a wedding and enjoy themselves, not to act as the subjects for your camera. Side-mounted flash has avoided the problem of red-eye.

PHOTOGRAPHER:
Ami Ghale
CAMERA:
35mm
LENS:
50mm
FILM:
ISO 200
EXPOSURE:
⅟₆₀ second at f11
LIGHTING:
Accessory flash

▶

With all the formalities of the wedding day finally over, the newlyweds are seen here in this portrait completely relaxed and obviously very happy. The flash coverage is just sufficient for the subjects, and the background is far enough away not to have picked up any light spilling past them, producing an eyecatching lighting effect that really punches the figures forward in the frame. The highlights reflecting back from the bride's hand jewellery and rings are just a bonus, adding a romantic sparkle to the image.

PHOTOGRAPHER:	FILM:
Ami Ghale	**ISO 200**
CAMERA:	EXPOSURE:
35mm	**⅟₆₀ second at f11**
LENS:	LIGHTING:
90mm	**Accessory flash**

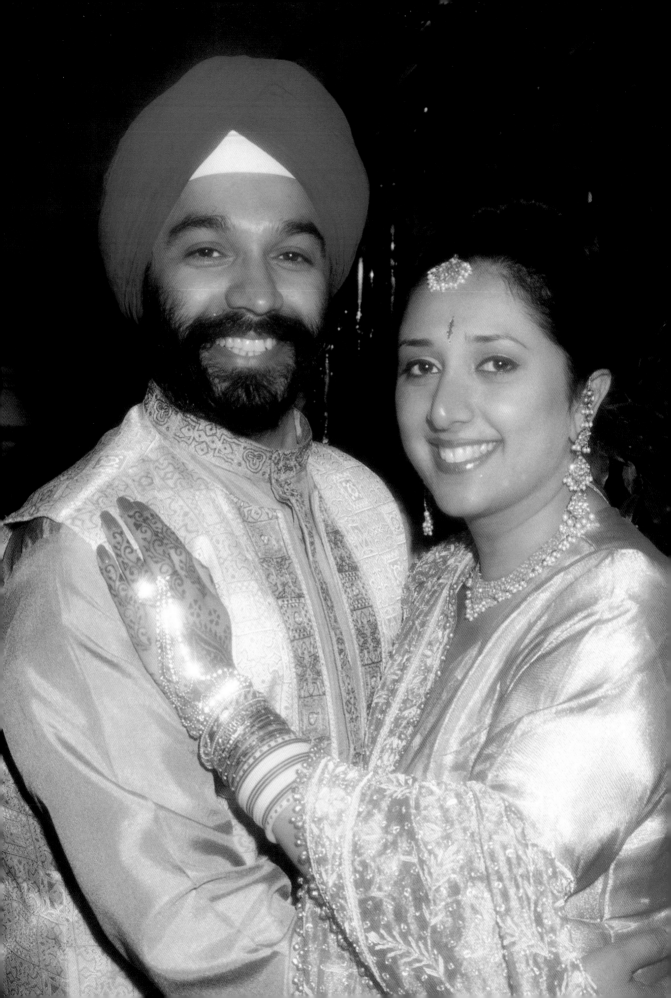

Hindu wedding

PHOTOGRAPHER:
Majken Kruse
CAMERA:
35mm
LENS:
90mm
FILM:
ISO 100
EXPOSURE:
⅛₂₅ second at f5.6
LIGHTING:
Daylight and diffused accessory flash

WITH A RELIGION AS WIDESPREAD AND DIVERSE AS HINDUISM there is no one form of the wedding service – the precise forms of the ceremonies and rituals will depend not only on the country of origin of the participants but also which part of the country they come from, social status and, of course, financial resources. But in keeping with all other religions and cultures, a wedding always ranks highly in significance in the calendar of Hindu community affairs, joining, as it does, not simply two individuals but also forging a union between two families.

If you have been commissioned to be the official photographer at a Hindu wedding or any other wedding celebration and you are not familiar with the form of the service or the significance of the rituals involved, you must spend some time researching this subject if you are to do a proper job. Some Hindu temples produce information leaflets explaining much of this, not only for non-Hindus who may be attending but also for Hindus living in predominantly non-Hindu societies and who may have lost touch with their original language, cultural practices and religious beliefs. Because of the often high numbers of people invited to a wedding, however, wedding ceremonies often

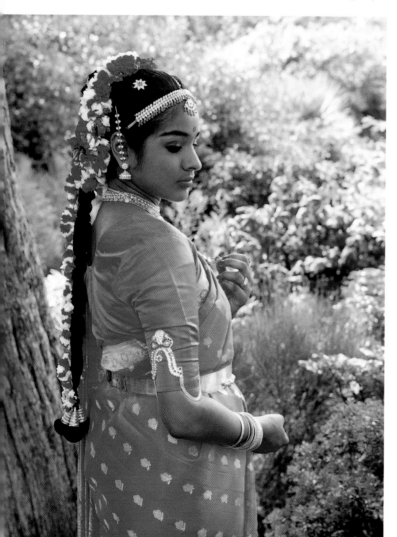

There was very little time on the day of the wedding itself to take this type of shot before the ceremonies were to begin, so the photographer had already scouted out a good location some days before in order to save time. She knew the colour of the bride's sari and had seen pictures of the type of floral decoration and headdress she would be wearing, and so selected a location that was attractive but consisted predominantly of foliage plants (brightly coloured garden flowers in the surroundings would have invited colour clashes and distracted from the subject). Both you and the client need to be flexible over the timing of photo sessions outdoors, since you can never guarantee the weather you need.

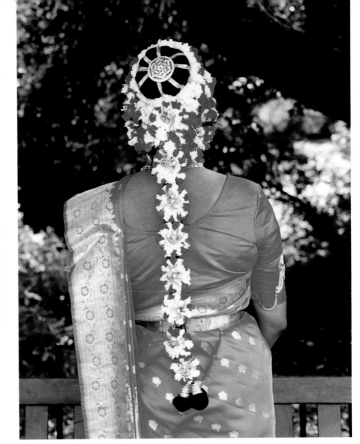

▶

Moving the subject out of direct sunlight and into open shade has had the effect of strengthening colours, and it has also helped to show the wonderful contrasts between the red and white flowers in the bride's elaborate headdress and those woven into her long, plaited hair.

PHOTOGRAPHER:	FILM:
Majken Kruse	ISO 100
CAMERA:	EXPOSURE:
35mm	⅟₆₀ second at f4
LENS:	LIGHTING:
90mm	Daylight only

take place in rented function rooms and not in the temple itself, which, in many instances, would probably be too small to cope.

Even if you are familiar with the form of the wedding ceremony, have at least one meeting before the big day with the families of the bride and groom to finalize the shooting list. As well as the ceremony itself, you may be required to take shots of the bride's preparations for

▶

Back at the family home, the photographer took the opportunity to shoot some candid pictures of the bride's final preparations. Trying to blend into the background as much as possible and not use flash, the photographer decided to rely on daylight from the windows – but this meant that she had to take a light reading only from the shadow side of the subject's profile that was facing the camera. A general light reading from the room would have underexposed the subject's skin tones. It is interesting to note the effect that different lighting intensities and lighting directions has on the colour of the bride's silk sari when compared with the other daylit shots here.

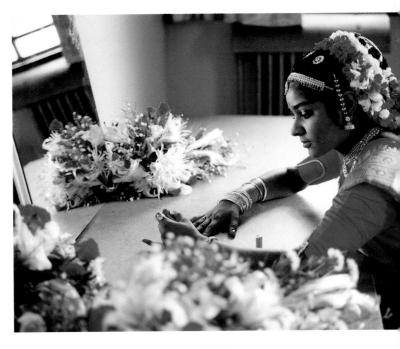

PHOTOGRAPHER:	FILM:
Majken Kruse	ISO 100
CAMERA:	EXPOSURE:
35mm	⅟₆₀ second at f4
LENS:	LIGHTING:
35mm	Daylight only

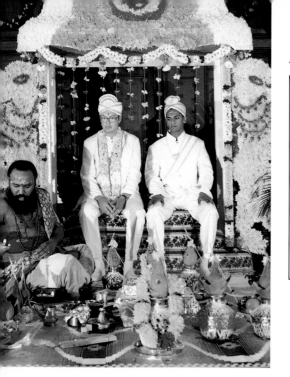

Leaving the bride's home some time before the start of activities, the photographer had to get to the function rooms well in advance in order to take some shots of another part of the wedding ceremony. The groom arrives first to be greeted by the bride's brother (or other close male family member if there is no brother). Together they sit under a canopy of fresh flowers as the officiating priest makes ready to begin.

PHOTOGRAPHER:
Majken Kruse
CAMERA:
35mm
LENS:
80–210mm zoom (set to 80mm)
FILM:
ISO 100
EXPOSURE:
⅟₆₀ second at f8
LIGHTING:
Studio flash

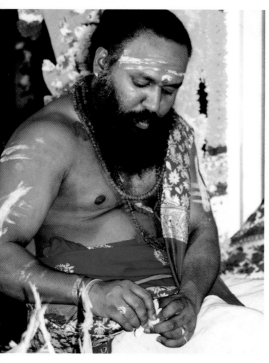

Remember to take every opportunity to shoot close-ups of all important personnel involved in the wedding. Here the photographer squatted down to bring the camera down to about the eye level of the priest sitting cross-legged on the floor. Priests are of the highest, Brahman, caste. Orthodox Hindus always have a family Brahman priest and so this man would be well known to the family, rather than being simply an anonymous official.

the wedding and then be expected to be at the reception and party afterwards. If, for example, family and friends are attending from far-away places, it could be an important part of the coverage to make sure that they feature in at least some of the photographs you take. And if you do not know who these people are or what they look like, make sure that a family member is responsible for pointing them out to you. Getting this type of detail right ensures that you not only have a satisfied client but you also increase your chances of obtaining repeat business through personal recommendations. Most wedding photographers will readily admit that they receive most of their business through word-of-mouth recommendations rather than through any form of paid advertising.

PHOTOGRAPHER:
Majken Kruse
CAMERA:
35mm
LENS:
80–210mm zoom (set to 170mm)
FILM:
ISO 100
EXPOSURE:
⅟₆₀ second at f8
LIGHTING:
Studio flash

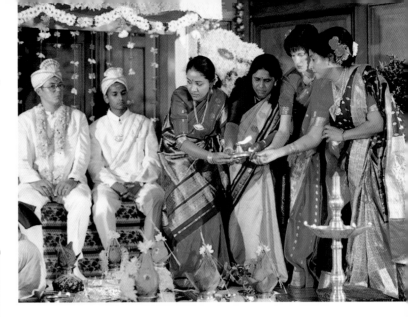

At this stage the bride has still not arrived and the immediate female members of the family can be seen performing *arti* – each helps to hold the oil lamp (filled with ghee) while they move it in a circular motion. This is part of a prayer, usually to Ganesh or the Lord Shiva, to bring luck and safety to the bride and groom.

PHOTOGRAPHER:	FILM:
Majken Kruse	ISO 100
CAMERA:	EXPOSURE:
35mm	¹⁄₆₀ second at f5.6
LENS:	LIGHTING:
80–210mm zoom (set to 80mm)	Studio flash

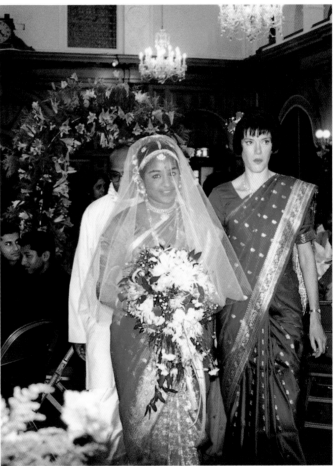

Alerted to the bride's imminent arrival, the photographer had to position herself in the lobby area of the function rooms in order to take this shot, showing the bride accompanied by the groom's sister. The studio flash set up for the wedding ceremony itself was left in position and the photographer relied here on accessory flash instead. Even a powerful accessory flash could not hope to light an entire area of this size, and you can see in the more distant areas the colour cast of domestic tungsten. Rather than being a problem, however, this warm orange colouration adds to the atmosphere.

PHOTOGRAPHER:	EXPOSURE:
Majken Kruse	¹⁄₆₀ second at f8
CAMERA:	LIGHTING:
35mm	Accessory flash and
LENS:	available domestic
50mm	tungsten
FILM:	
ISO 100	

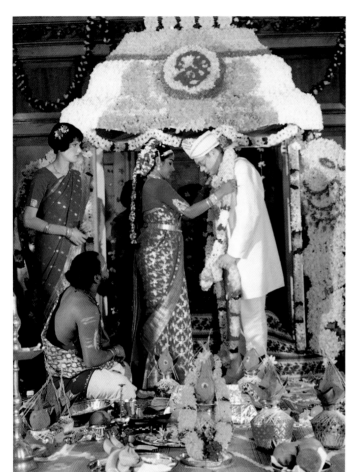

This is the first time the bride and groom see each other on their actual wedding day. Beneath the flower canopy they face each other with garlands in their hands. First, the bride places a garland over the head of her husband-to-be, then he performs the same ritual. The ritual of presenting flower garlands as a greeting can be found in many Asian and European cultures, but for orthodox Indian Hindus flowers have a particular spiritual significance.

PHOTOGRAPHER:	FILM:
Majken Kruse	ISO 100
CAMERA:	EXPOSURE:
35mm	1/60 second at f5.6
LENS:	LIGHTING:
80–210mm zoom (set to 80mm)	Studio flash

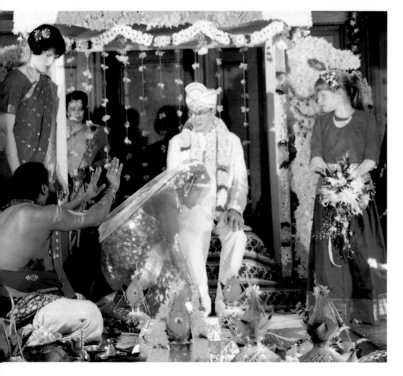

As a sign of respect, the bride bends down to touch the foot of the groom as the priest blesses them. The contrast in the faces of the witnesses here is interesting – the look of understanding and approval on the face of the bride's mother and the rather more dubious expressions on the faces of the groom's relatives either side of the canopy. In the next part of this wedding ceremony, the groom washes the feet of his bride as part of the ritual cleansing.

PHOTOGRAPHER:	FILM:
Majken Kruse	ISO 100
CAMERA:	EXPOSURE:
35mm	1/60 second at f5.6
LENS:	LIGHTING:
80–210mm zoom (set to 80mm)	Studio flash

Representing abundance and the source of life, the coconut, which all participants here can be seen touching, was a central symbol in the ceremony.

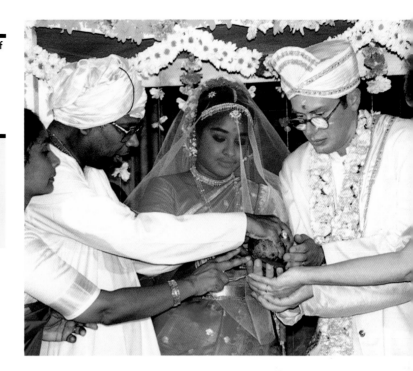

PHOTOGRAPHER:
Majken Kruse
CAMERA:
35mm
LENS:
80–210mm zoom (set to 210mm)

FILM:
ISO 100
EXPOSURE:
⅟₆₀ second at f5.6
LIGHTING:
Studio flash

Moving away from centre stage where the canopy had been erected, which also corresponded to the area the photographer had set the studio flash to cover, the couple and priest offer a prayer. To take this shot, the photographer had to use accessory flash, since moving the studio unit would have been disruptive and have taken far too long. A high degree of flexibility is required of wedding photographers, since no matter how thorough your preparations you can never predict every eventuality.

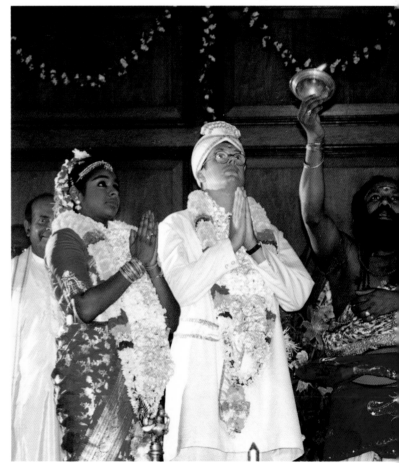

PHOTOGRAPHER:
Majken Kruse
CAMERA:
35mm
LENS:
35mm

FILM:
ISO 100
EXPOSURE:
⅟₆₀ second at f5.6
LIGHTING:
Accessory flash

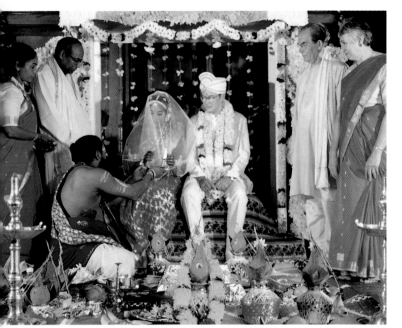

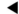

Shots such as this are particularly significant since they show all the major players – the bride and groom sitting centre stage, the bride's parents on the left, the groom's parents on the right, the priest and, in the foreground, all of the ritual paraphernalia used in the different stages of the wedding ceremony.

PHOTOGRAPHER:	FILM:
Majken Kruse	**ISO 100**
CAMERA:	EXPOSURE:
35mm	**⅟₆₀ second at f8**
LENS:	LIGHTING:
80–210mm zoom (set to 90mm)	**Studio flash**

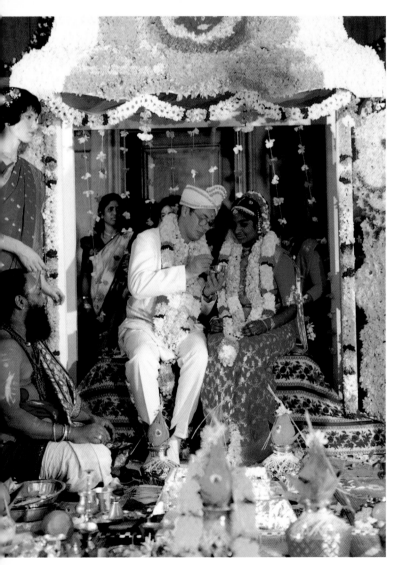

The ceremony is over at this stage and the bride and groom, now man and wife, return to their places under the wedding canopy. Note that the couple have swapped sides, and now the woman is sitting on the man's left. This indicates that they are indeed a married couple.

PHOTOGRAPHER:	FILM:
Majken Kruse	**ISO 100**
CAMERA:	EXPOSURE:
35mm	**⅟₆₀ second at f5.6**
LENS:	LIGHTING:
80–210mm zoom (set to 80mm)	**Studio flash**

▶

After the ceremony has concluded and before all the relevant people disburse to the party or simply become too busy to give you any time, set up a series of detailed close-ups, such as the hands of the newlyweds or the bride praying, as well as more classic wedding images, such as the bride and groom together with the other major participants.

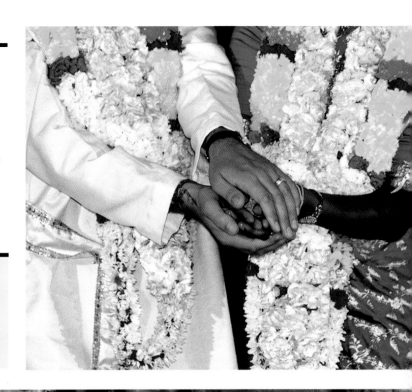

PHOTOGRAPHER: **Majken Kruse**	FILM: **ISO 100**
CAMERA: **35mm**	EXPOSURE: **1/60 second at f8**
LENS: **80–210mm zoom (set to 135mm)**	LIGHTING: **Studio flash**

PHOTOGRAPHER:
Majken Kruse
CAMERA:
35mm
LENS:
80–210mm zoom (set to 180mm)
FILM:
ISO 100
EXPOSURE:
1/60 second at f5.6
LIGHTING:
Studio flash

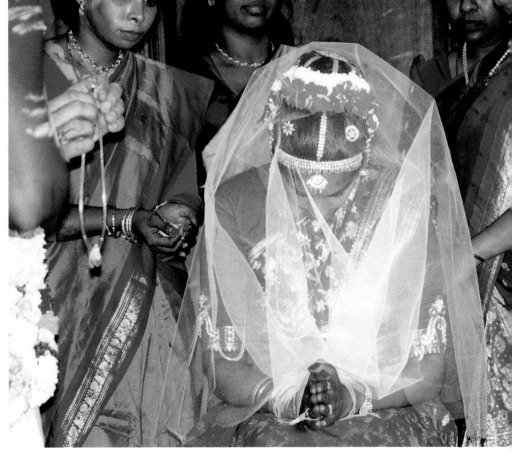

Wedding snapshots

PHOTOGRAPHER:
**Souza/Liaison/
Frank Spooner
Pictures/Gamma**
CAMERA:
35mm
LENS:
55mm
FILM:
ISO 200
EXPOSURE:
⅛₂₅ second at f5.6
LIGHTING:
Daylight only

EVERY WEDDING, NO MATTER WHAT FORM THE CEREMONY takes or the religious or ethnic background of the participants, is full of special moments that have little to do with the obvious wedding rituals involved. For the alert photographer, candid shots of the interactions between the happy couple and their relatives, for example, or between friends who perhaps haven't seen each other for a long time, the table settings for the wedding party, and the many little private cameo scenes that inevitably occur, can make all the difference to the coverage of the occasion. It is the care you take over this type of detail, as a supplement to the agreed shot list, that can make all the difference to the way your clients react to the portfolio of pictures you present, and help to ensure that you receive plenty of positive word-of-mouth recommendations.

For the set-piece photographs, many wedding photographers rely on medium-format cameras – 6 x 7cm, 6 x 6cm or 6 x 4.5cm – because of the extra quality these bigger negatives give when enlargements are called for. For the more candid coverage, however, it might be better to use a 35mm SLR because of its relative lightness and ease of operation. The film, processing and printing costs, too, are all

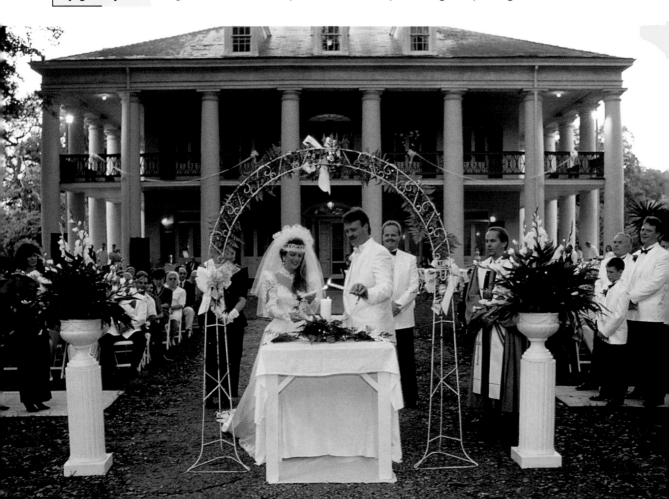

▶

The groom at this Islamic wedding ceremony had proved to be a not particularly relaxed subject, and so the photographer gratefully took the opportunity to shoot this picture of him, smiling at last, as he interacted with one of the members of his family.

PHOTOGRAPHER:	FILM:
Bertrand Rieger/	ISO 100
Frank Spooner	EXPOSURE:
Pictures/Gamma	¹⁄₆₀ second at f5.6
CAMERA:	LIGHTING:
35mm	Mixed available
LENS:	light
90mm	

◀

While moving discretely, and at quite some distance, past the bride and groom, who were nearing the end of their vows, in order to get into position to record them turning towards their seated friends and family at the conclusion of the ceremony, the photographer noted the couple lighting candles from a central flame. Stopping immediately, the photographer grabbed the opportunity to snap this charming and unexpected record of the day.

cheaper than for medium format models, and watching the budget is important if you want to show a good profit for your labours. Top-of-the-range 35mm cameras and lenses produce excellent results that easily stand up to reasonable-sized enlargement.

Bear in mind, however, that if you are intending to swap between one camera format and another than you must be equally familiar with both. Any hesitancy or fumbling with the controls on your part could result in missed opportunities.

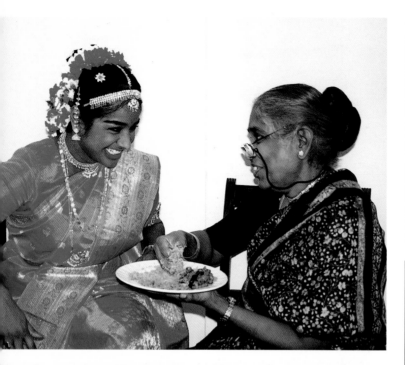

Pictures such as this, although not planned for or part of any prearranged shooting list, can represent cherished memories for those depicted. Here, a Hindu bride, relaxed and very happy at the conclusion of the formalities of her wedding ceremony, is being fed by her grandmother. The affection between the pair is evident, and the importance of images such as this can only become greater as the years pass.

PHOTOGRAPHER:	FILM:
Majken Kruse	**ISO 100**
CAMERA:	EXPOSURE:
35mm	**⅟₁₂₅ second at f8**
LENS:	LIGHTING:
80–210mm zoom (set at 100mm)	**Reflected accessory flash**

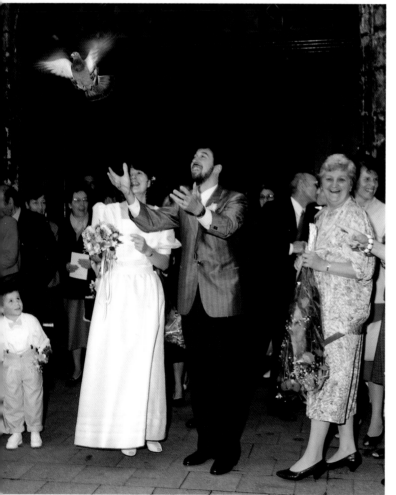

Although the photographer had met the bride and groom before their wedding ceremony to discuss their pictures requirements, at no point was it mentioned to her that they planned to release a pigeon on the steps of the church as a symbolic gesture. It was only her quick reactions that ensured this happy moment was recorded. If, however, the camera had not already been set up for one of the set-piece pictures, she probably would have missed it altogether.

PHOTOGRAPHER:	FILM:
Anne Kumps	**ISO 100**
CAMERA:	EXPOSURE:
6 x 6cm	**½₂₅₀ second at f8**
LENS:	LIGHTING:
50mm	**Daylight only**

When the bride and groom and their families have gone to so much trouble and spent so much money on creating a beautiful setting for the wedding party, take at least a few pictures to include in your picture presentation – even if they are not a part of the agreed shot-list. Just a few minutes before the guests were to be called into the dining room, and with all the candles freshly lit, the photographer set up her tripod and took a series of pictures of the table settings. She opted to use the available candle light as the principal illumination (there were ceiling spotlights as well), since any form of flash lighting she had with her would have been inadequate for the area involved – and, in any case, flash would have destroyed the romance and atmosphere of the scene.

PHOTOGRAPHER:
Majken Kruse
CAMERA:
6 x 7cm
LENS:
55mm
FILM:
ISO 100
EXPOSURE:
½ second at f8
LIGHTING:
Candle light and available domestic tungsten

A wonderful picture such as this is all down to a vigilant photographer and quick reflexes. Alerted by an excited shriek behind her, the photographer spun around to see these old friends falling into each other's arms. Shooting quickly for a perfect candid image, she learned later that the ladies had not seen each other for many years until both meeting again at this wedding reception.

PHOTOGRAPHER:
Anne Kumps
CAMERA:
35mm
LENS:
35mm
FILM:
ISO 200
EXPOSURE:
⅟₆₀ second at f8
LIGHTING:
Accessory flash

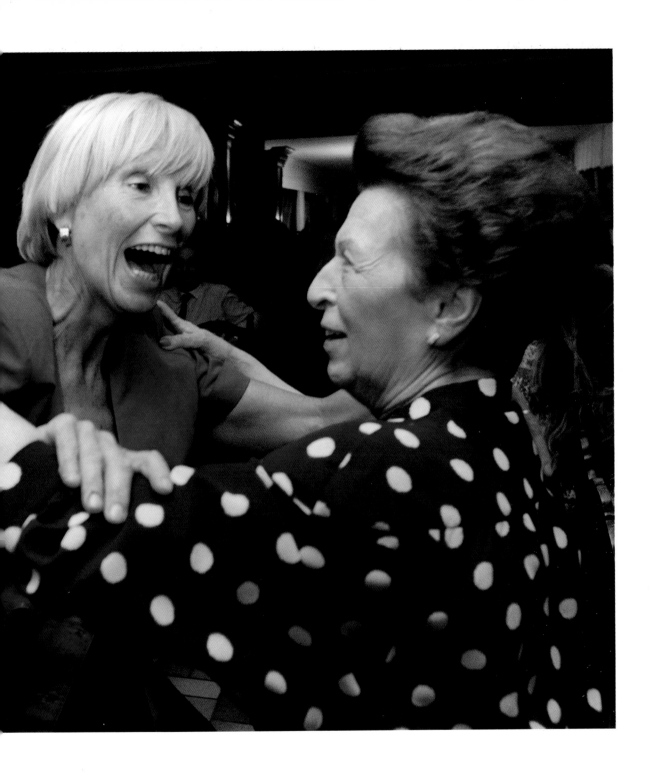

Directory of photographers

Kate Dawson
Desmures
BP 27
73440 Le Menuires
France
Telephone: + 33 479 880473

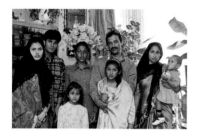

Lesley Ann Fox
Victoria House Studio
The Moor
Hawkhurst
Kent TN18 4NR
UK
Telephone: + 44 1580 754440
Fax: + 44 1424 775921

Lesley Ann Fox was a keen amateur photographer until her late twenties, when she took the opportunity to train for a year with a local commercial photographer. For the next five years she worked part time for the studio photographing weddings before founding her own, home-based, business. Within three years she had opened a small studio in the Weald of Kent. Two years on and she has an established thriving business and covers about 40 weddings and 150 portrait sessions each year.

Frank Spooner Pictures
Unit B7
16–16A Baldwins Gardens
London EC1 7US
UK
Telephone: + 44 171 6325800
Fax: + 44 171 6325828

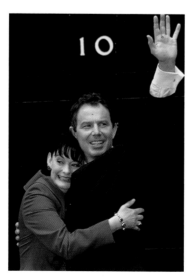

Rudi Fransens
Foto Fransens
Tervuursesteenweg 153
3060 Bertem
Belgium
Telephone: + 32 16 480946

John Freeman
The Loft Studio
Enterprise House
59/65 Upper Ground
London SE1 9PQ
UK
Telephone: + 44 171 8279393
Fax: + 44 171 8279394

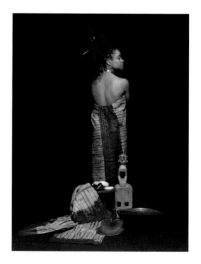

Richard Galloway
19 Heathfield Road
Acton
London W3 8EH
UK
Telephone: + 44 181 9935228

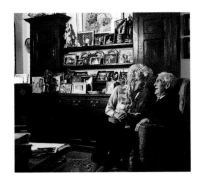

Ami Ghale
36 Audley Way
Ascot
Berkshire SL5 8EF
UK
Telephone: + 44 1344 882380

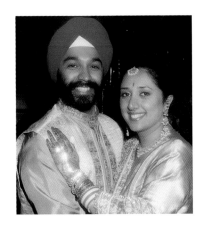

Trevor Godfree
Trevor Godfree Associates –
Photographers
Cherry Orchard Farmhouse
Hunt Street
West Farleigh
Maidstone
Kent ME15 0ND
UK
Telephone & fax: + 44 1622
817835

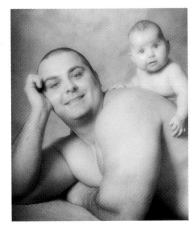

Trevor trained at the Ealing
School of Photography before
becoming an Associate of the
British Institute of Professional
Photography. He has been a
professional photographer for
more than 20 years, specializing
in 'people' photography for
magazines and company reports.
His style is essentially informal, in
both black and white and colour.
Trevor is the winner of two
Kodak portrait awards.

Matt Griggs
United Northern Photographers
4 Lower Green
Baildon
Bradford BD17 7NE
UK
Telephone: + 44 956 666791

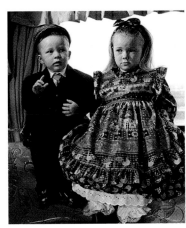

Robert Hallmann
72 Castle Road
Hadleigh
Benfleet
Essex SS7 2AT
UK
Telephone: + 44 1702 557404

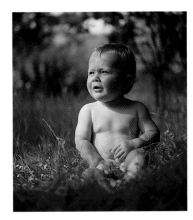

Majken Kruse LBIPP
11 East Court
South Horrington Village
Wells
Somerset BA5 3HL
UK
Telephone: + 44 1749 671571

Majken is a professional
photographer with an active
photographic practice
specializing in weddings and
portraiture. She started her

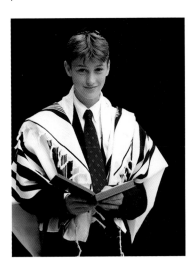

working career in front of the camera as a model. At that time, photography was more of a hobby, albeit an important one. This experience, and a natural eye for photographic composition, led her to taking up photography professionally. Majken initially concentrated on children and general portraiture before widening her photographic interests. She firmly believes that her experience in front of the camera helps her to relate to, and work effectively with, her subjects to achieve a natural look. Her creative talent, together with years of experience, are reflected in a very individual style.

Anne Kumps

Leuvensebaan 334
3040 St Agatha Rode
Belgium
Telephone & fax: + 32 16 472635

Anne Kumps has been a freelance photographer since 1983. Although at ease with a wide range of commissions, Anne has a particular interest in

portraiture and photographing children. Her success she puts down to two guiding principles: an open approach to her subjects and a huge amount of patience.

Popperfoto

The Old Mill
Overstone Farm
Overstone
Northampton NN6 0AB
UK
Telephone: + 44 1604 670670
Fax: + 44 1604 670635

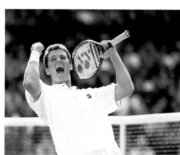

Tim Ridley

Wells Street Studios
70–71 Wells Street
London W1P 3RD
UK
Telephone: + 44 171 5805198
Fax: + 44 171 3233690

Tim Ridley is an established freelance photographer, having started in the business more than 15 years ago as a photographic assistant. In his West End studio in central London, Tim

specializes in publishing, public relations, and design group clients. Recently, a series of Tim's photographs won him a place in the annual Association of Photographers competition. His favourite medium is black and white and he particularly enjoys working with both children and animals.

Linda Sole

33 Coleraine Road
London SE3 7PF
UK
Telephone: + 44 181 8588954
Fax: + 44 181 7398840

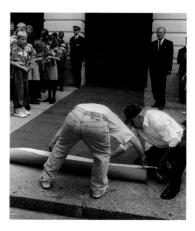

Born in 1943 in County Durham, Linda Sole now lives and works in southeast London earning her living as a freelance photographer concentrating principally on reportage and photo-documentary. Linda joined the Independent Photographers' Project in 1983, organizing workshops and photographic local events. Teaching photography has been a strand running through Linda's career, and she has taught and lectured on photography at various schools and colleges in Britain and abroad. She was also resident photographer at Blackheath Concert Halls between 1991 and 1993, where she held two exhibitions of her work. She also taught photography in France while working for a theme holiday company. As well as exhibiting regularly at Hays Gallery in Deptford, London, Linda is also the winner of numerous photographic competition awards.

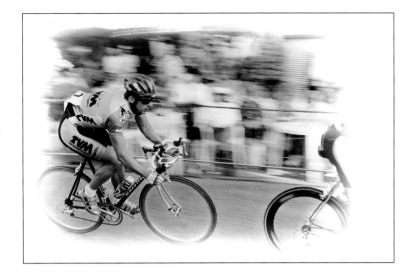

Jos Sprangers FBIPP
Dorpstraat 74-76
4851 CN Ulvenhout
The Netherlands
Telephone: + 31 76 613207
Fax: + 31 76 601844

As well as being a Fellow of the British Institute of Professional Photography, Jos is also a qualified member of the Dutch Institute of Professional Photography. In 1970 Jos started his own business, combining photographic retailing with general photographic work. By 1980, however, he abandoned the retailing side completely to concentrate solely on undertaking commissioned photography. He is a three-time winner of the Camera d'Or. Throughout the years Jos has won many prestigious competitions, culminating in being judged Brides Photographer of the Year (England) in two consecutive years. As well as running his business as a professional photographer, Jos has also been invited to lecture not only in his native Holland, but also in Belgium, Germany, England, Scotland, Norway and Cyprus.

Janine Wiedel
8 South Croxted Road
London SE21 8BB
UK
Telephone & fax: + 44 181 7611502

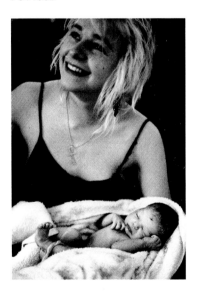

Aknowledgements

In large part, the production of this book was made possible because of the contributions of the many photographers featured, some of whom permitted their work to be reproduced free of charge, and the publishers would like to acknowledge their most valued and generous contribution.

The author and publishers would also like to thank the many individuals and organizations who gave their support, technical assistance and services during the production of this work, in particular Brian Morris and Barbara Mercer at RotoVision SA, Anne-Marie Ehrlich and Samantha Larrance at E.T. Archive, and all of the manufacturers and distributors whose equipment appears at the beginning of this book.